CW00816349

CHICKASAW

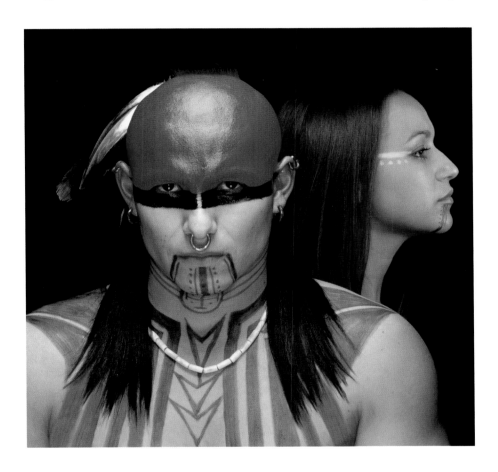

CHICKASAW
Unconquered and Unconquerable

PHOTOGRAPHY BY DAVID G. FITZGERALD

ESSAYS BY JEANNIE BARBOUR, AMANDA COBB, AND LINDA HOGAN

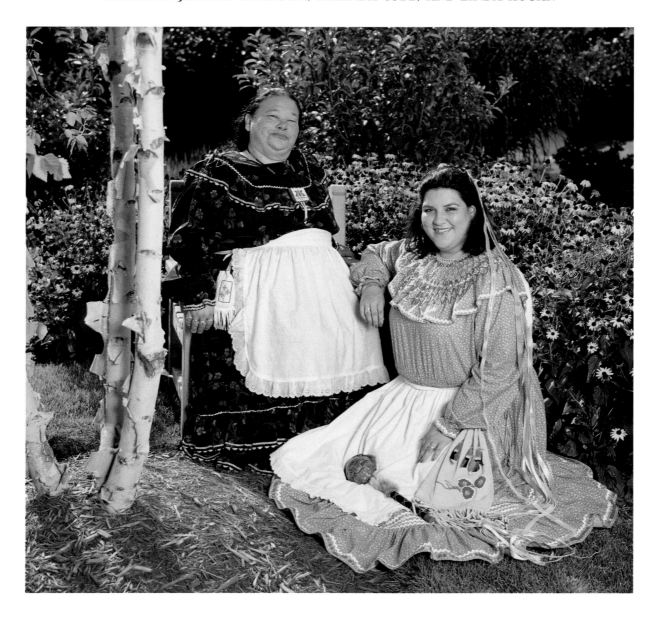

Introduction by BILL ANOATUBBY, Governor of the Chickasaw Nation

CHICKASAW PRESS

This book is

respectfully dedicated to

the Chickasaw people.

Chickasaw Press
P.O. Box 1548
Ada, Oklahoma 74820

Produced by
✖ Graphic Arts Center Publishing®
A service mark of Graphic Arts Center Publishing Co.
P.O. Box 10306, Portland, Oregon 97296-0306
503/226-2402
www.gacpc.com

Library of Congress Cataloging-in-Publication Data

Fitzgerald, David, 1935-
 Chickasaw : unconquered and unconquerable /
photography by David Fitzgerald ; essays by Jeannie
Barbour, Amanda Cobb, Linda Hogan ; introduction by
Bill Anoatubby.
 p. cm.
 The homelands — Rebuilding a nation — Our fire —
Chickasaw nation today — Chickasaw portraits.
 Includes bibliographical references and index.
 ISBN-13: 978-1-55868-992-3 (hardbound) 1.
Chickasaw Indians—History. 2. Chickasaw Indians—
Social life and customs. I. Barbour, Jeannie. II. Cobb,
Amanda J., 1970- III. Hogan, Linda. IV. Title.
 E99.C55F58 2006
 976.6'500497386—dc22
 2006022938

Designed by Elizabeth Watson

Printed and bound in the United States of America

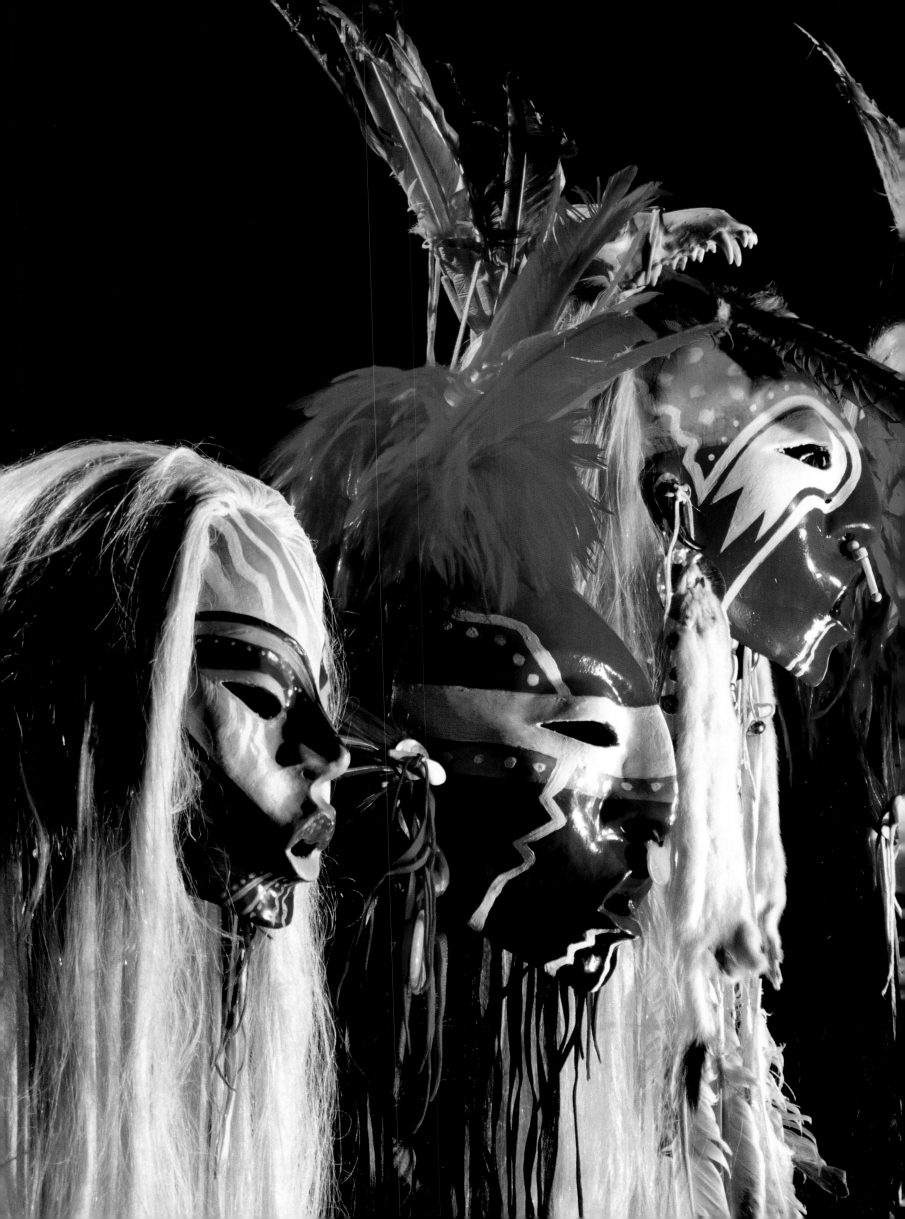

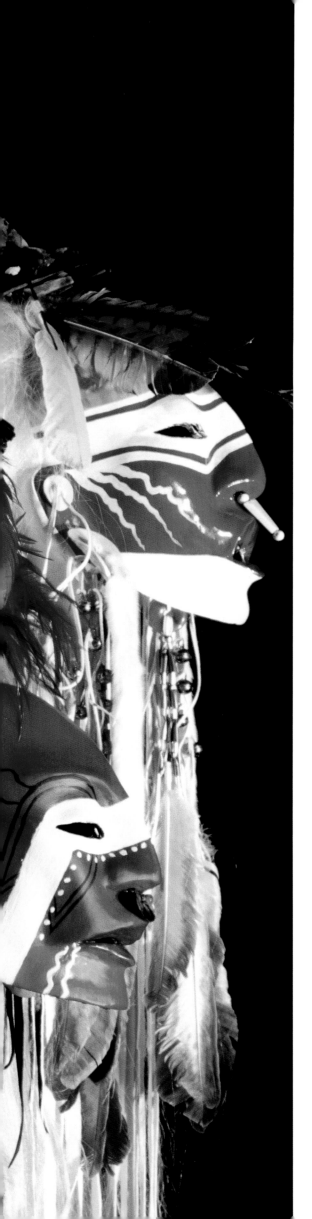

CONTENTS

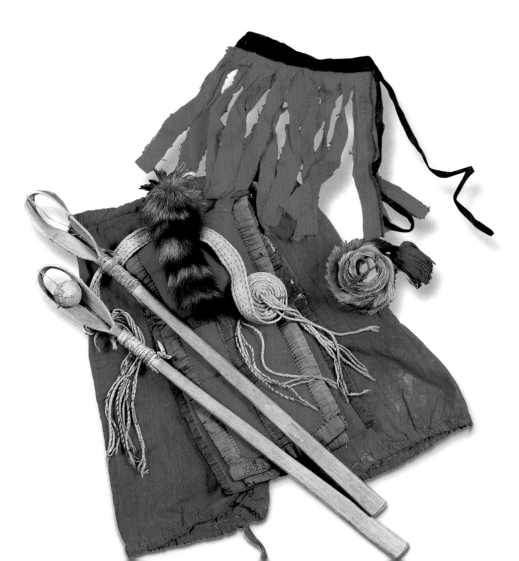

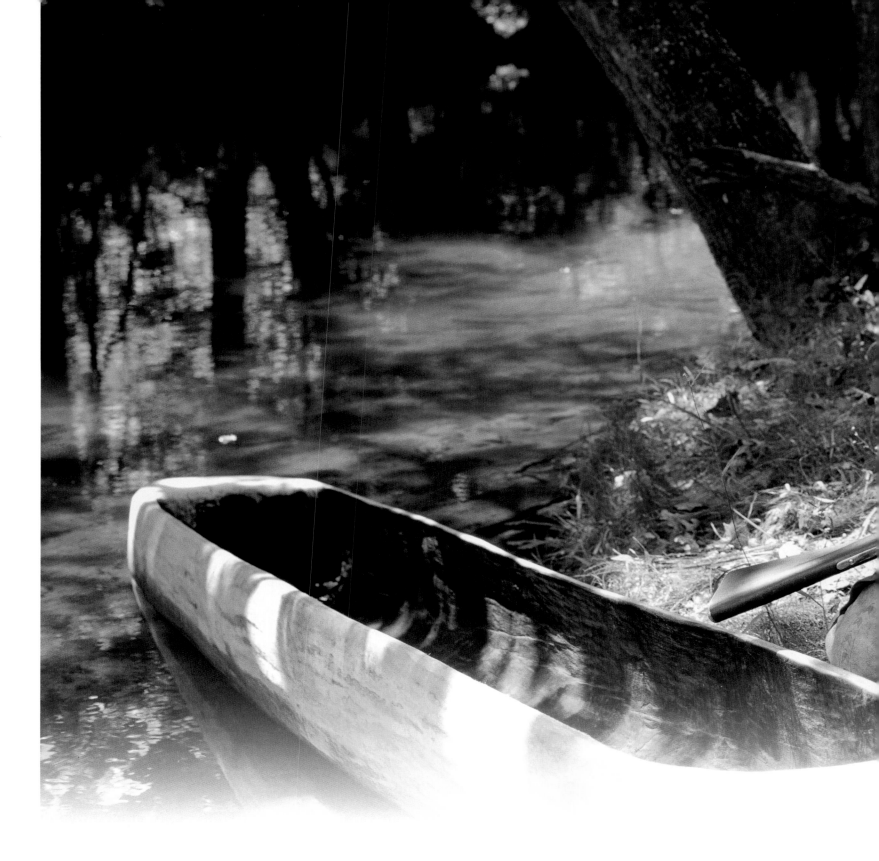

Prehistory
Migration of Chickasaws to new homelands in the Southeastern part of (now) North America

1200
Extensive trade network exists throughout North American continent

1250
Mississippian Period, effigy pottery

1300
Woodpecker shell gorget

1400
Decline of Mound Builders society

1450
Evidence of prehistoric Chickasaw villages in eastern Mississippi region

1500
Prehistoric Chickasaw pottery

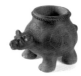

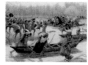

1540
Hernando de Soto stumbles into Chickasaw villages

1670
French explore Mississippi River and pass through Chickasaw territory

1690
English and French establish trade alliances with Chickasaw people

1700s
French-Indian Wars

1730
Natchez take refuge in Chickasaw territory

1736
Battle of Hikea (Akia): French and Choctaw attack small Chickasaw village; Chickasaws are victorious

1781
Chickasaws battle Spanish in support of England during Revolutionary War

1786
Treaty of Hopewell signed, officially ending hostilities between Chickasaws and Americans

1796
Death of Piomingo, major leader of Chickasaw people

1830
Indian Removal Act

1832
Treaty of Pontotoc: Chickasaws agree to leave homelands

1837
Treaty of Doaksville signed; first group of Chickasaws leave homelands for Indian Territory

1200–1300 **1400** **1500** **1600** **1700** **1780–1790** **1800**

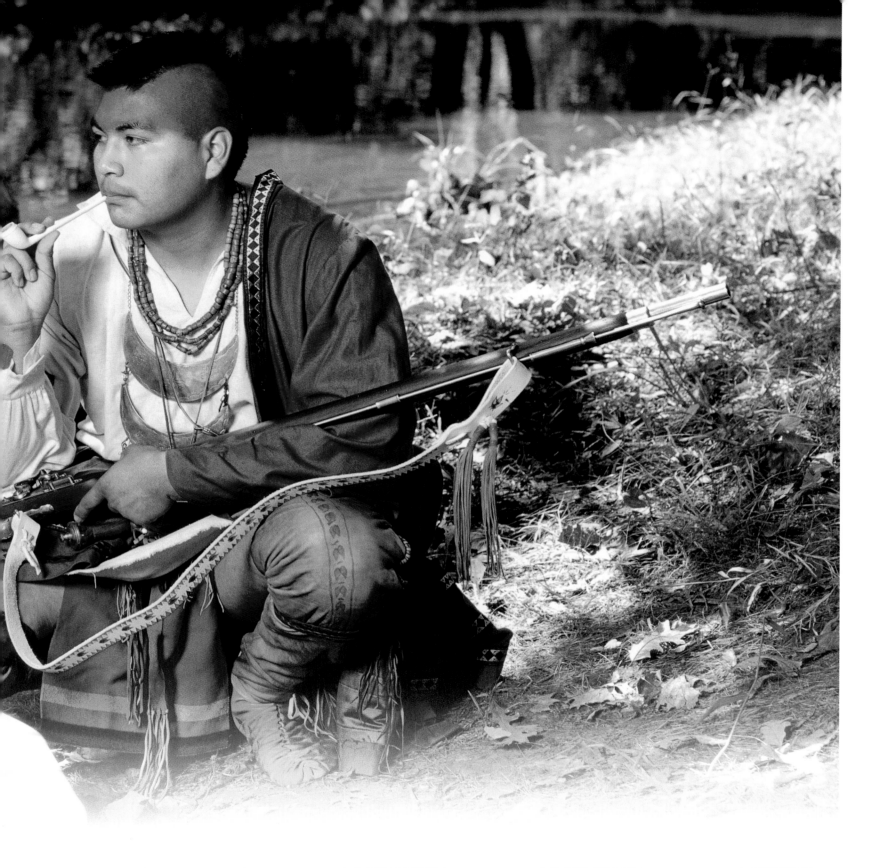

1850
Chickasaws exist as part of Choctaw government in Indian Territory

1855
Chickasaws petition federal government for separation from Choctaws

1856
Chickasaw constitution written and government established

1861
Chickasaw Nation declares independence from United States; enters Civil War on side of Confederacy

1880s
Golden Age of Chickasaw boarding schools

1897
Atoka Agreement

1898
Curtis Act; Chickasaw national capitol dedicated

1906
Chickasaw Nation government liquidated. Douglas Johnston appointed governor by federal government

1907
Statehood for Oklahoma

1960
Chickasaw people involved in movement to reinstate their government

1963
President John F. Kennedy appoints Overton James governor of Chickasaws

1966
Chickasaw Housing Authority established

1971
First sanctioned election since 1904: Overton James elected governor by Chickasaw people

1975
Chickasaw headquarters built in Ada, Oklahoma

1979
First Lieutenant Governor elected: Bill Anoatubby

1983
Modern Chickasaw Constitution ratified

1987
Bill Anoatubby elected governor of Chickasaw Nation

1993
Chickasaw Nation becomes self-governed tribe

2002
Chickasaw astronaut John Herrington carries tribal flag into space

2006
150-year celebration of 1856 Constitution

| 1850 | 1860–1880 | 1890 | 1900 | 1960 | 1970 | 1980–1990 | 2000 |

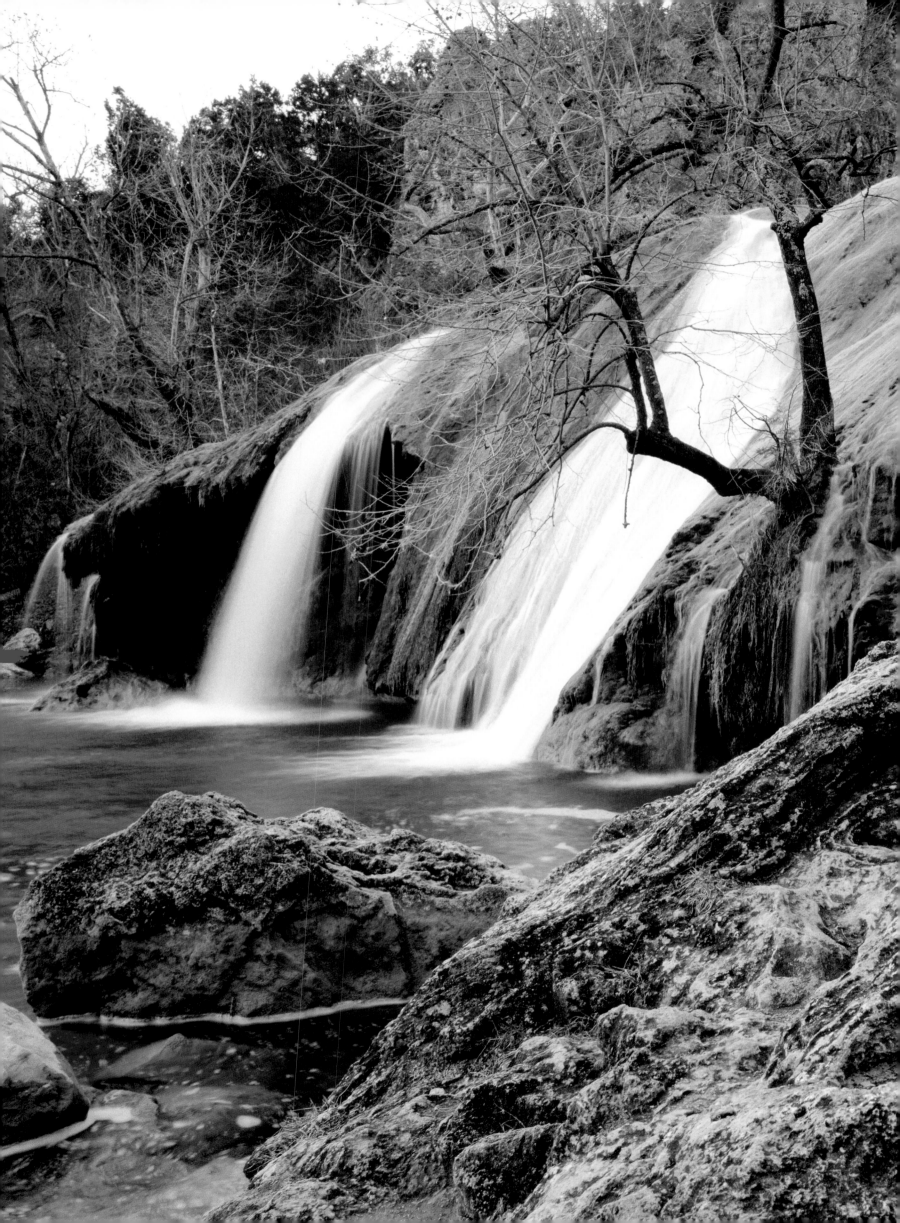

INTRODUCTION

CHICKASAW

by Bill Anoatubby

Governor of the Chickasaw Nation

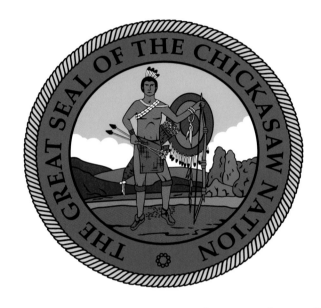

*The Chickasaw Nation is a collective mind-set and
determination rooted in community and loyalty to family.
Like the Hummingbird Warrior, it is ever vigilant,
industrious, energetic, and adaptable.*

The story of the Chickasaw Nation is one of survival, persistence, triumph, achievement, and beauty. It is the story of a people determined to not only survive, but to prosper and live well. Built with this fundamental ideal, Chickasaw government stands on a foundation that serves its people with the ebb and flow of history's events. It is a chronicle of unsurpassed natural splendor and spiritual connectivity to the land that can never be permanently separated from the hearts of Chickasaws. It is a collective mind-set and determination rooted in community and loyalty to family. Like the Hummingbird Warrior, it is ever vigilant, industrious, energetic, and adaptable.

Oral tradition tells us the earth began when Crawfish dove into the watery depths of the world and built the first landmass from mud at the bottom of the ocean. From these early beginnings all things good sprang to life, including the Chickasaw. It is interesting and insightful that our ancestors used the humble crawfish as the instrument employed by Ababinili to help fabricate the greatest of his creations. Size did not seem to matter. And like the crawfish and the hummingbird, the Chickasaw Nation has accomplished many great things throughout its history, even though its size was relatively small.

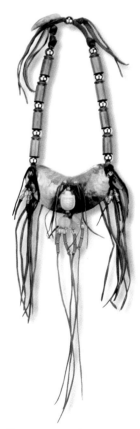

◄ TURNER FALLS IN THE ARBUCKLE
MOUNTAINS NEAR DAVIS, OKLAHOMA.

◄▲ GREAT SEAL OF THE CHICKASAW NATION.

▲ TRADITIONAL GORGET, BY JAMES BLACKBURN.

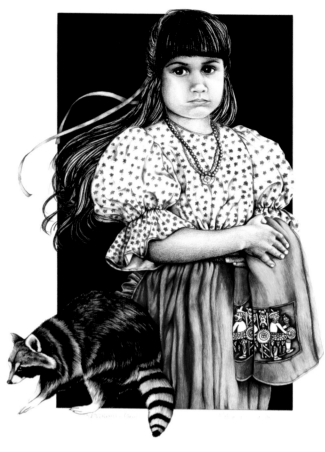

Our migration from "the place in the West" is probably the legend best known and loved by Chickasaws because it recounts the great journey our ancestors made to the promised homelands in what are now the states of Mississippi, Tennessee, Alabama, and parts of Kentucky. We lived happily there until first contact with European culture in 1540. From that point forward Chickasaws experienced a transformation in their culture viewed as detrimental, but also necessary. Life would never be the same, and our ancestors knew it. Most Chickasaws embraced elements of European ways of life while retaining aspects of Chickasaw traditions. In this way the tribe survived the tremendous social, economic, and governmental upheavals to come.

Our reputation as a dreaded warrior nation brought pause to outsiders when discussing the possibilities of battle with our people. Because we were deeply spiritual and abided by the religious constructs of the tribe, Chickasaw medicine was feared throughout the Southeast and beyond. The spiritual aspect of war was heavily ingrained in every aspect of Chickasaw life. The first priority of our leaders, the mikos, was developing an understanding of the tribe's enemies and cultivating policies and strategies to protect the people from any perceived threat. They were also adept at the arts of diplomacy and business. Although our historic relationship with others was often based on conflict and intrigue, trade was also an integral part of Chickasaw existence. In ancient times our national product came from the vast agricultural fields we generated and the numerous species of wildlife plentiful in the wilderness of the Chickasaw homelands. Our place of business was on the famous Natchez Trace and along the banks of the Tombigbee, Tennessee, and Mississippi Rivers. We dominated

▲ *OF THE RACCOON CLAN, NINETEENTH-CENTURY CHICKASAW GIRL, BY JEANNIE BARBOUR, CHICKASAW NATION PERMANENT COLLECTION.*

▶ *FIRST ENCOUNTER, CHICKASAWS MEET DESOTO, BY TOM PHILLIPS, CHICKASAW NATION PERMANENT COLLECTION.*

▶▲ *OF THE BIRD CLAN, NINETEENTH-CENTURY CHICKASAW BOY, BY JEANNIE BARBOUR, CHICKASAW NATION PERMANENT COLLECTION.*

▶▶ *WOODCUT BUST OF A CHICKASAW WARRIOR, BY BERNARD ROMANS, CA. 1775, IN A CONCISE NATURAL HISTORY OF EAST AND WEST FLORIDA, SMITHSONIAN COLLECTION.*

much of the waterway between the Gulf of Mexico and the Ohio Valley region. Trade benefited the tribe in much the same way as tribal business ventures do today. The proceeds were distributed among the people with regard for their personal needs and well-being.

The ancient Chickasaw clan system of family relationships and governmental authority remained somewhat intact despite the damaging effects of removal from the homelands in the mid 1800s. The clan system fostered a commitment to community, civic responsibility, and devotion to family. This belief in the sanctity of family life and the protection of each of its generations helped the Chickasaw Nation to survive the great tragedy of removal. It was instrumental in the restoration of the tribe in Indian Territory. Chickasaw people have always invested themselves in the well-being of others in their community. This love for their fellow tribesmen pulled Chickasaw society together and ultimately provided the catalyst needed to rebuild businesses, townships, and infrastructure for a new Chickasaw Nation in what would eventually become Oklahoma. Adequate attention to physical needs, education, financial stability, and social acceptance of each citizen were, and still are, paramount in maintaining a healthy community. Once again, our ancestors had the wisdom to understand what was required not only to survive, but to thrive in a new environment and cultural situation.

The clan structure of Chickasaw government eventually fell out of use and was replaced by our current three-branch system. Although the process of transformation was painful, change was necessary and the tribe adapted accordingly. The modern

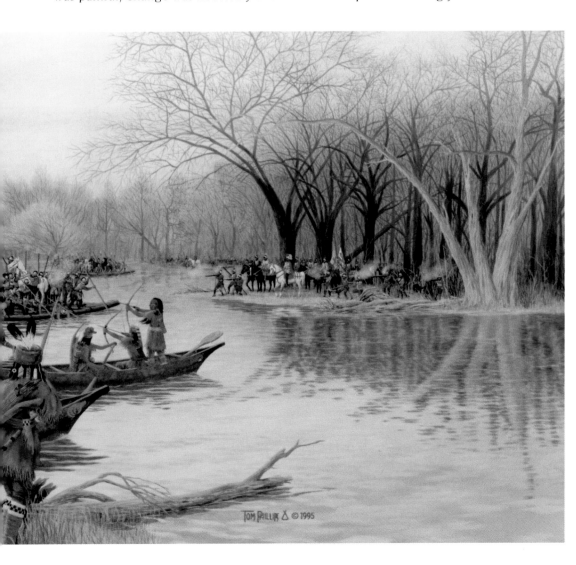

Tom Phillip © 1995

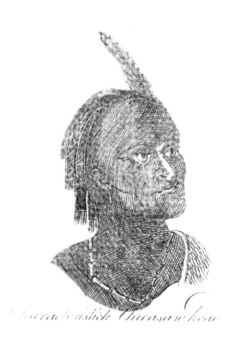

Chickasaw government consists of executive, legislative, and judicial branches similar to the federal government. Although its structure is very different from that of ancient Chickasaw government, the mission remains the same: enrichment and support of Indian lives.

The Chickasaw Nation land base exists in all or parts of thirteen counties in south central Oklahoma. It contains rich agricultural lands, hundreds of miles of rivers and lakes, majestic mountains, densely forested areas of vegetation, and quiet prairies. The earth is clean and the wind pure. It is a sacred land to Chickasaws—as sacred and beautiful as the land they were removed from over 160 years ago.

There is a unique quality about Chickasaws that distinguishes them from all other people on Earth. It is an intangible element that marks us as great. History pays tribute to it. We recognize it in one another, and the world has defined it as "unconquered and unconquerable." We are a proud people with the confidence of untold generations who have overcome every obstacle placed between themselves and success. This extraordinary book was created to pay tribute to every expression of the Chickasaw essence. Although photographer David Fitzgerald is not *Chikashsha* by blood, his photographs have distinguished him as such in spirit. We salute his efforts.

As we stand at the threshold of the twenty-first century, the Chickasaw Nation is confident of a bright future. Like those who came before us, we look to our children as the bearers of our great expectations. We endeavor to provide them with all they will need to assume the responsibilities of the next generation. They look to us to find their identity and, finally, to find their hummingbird wings.

▼ 1890 CHICKASAW CAPITOL BUILDING IN TISHOMINGO, OKLAHOMA. *COURTESY OF THE CHICKASAW COUNCIL HOUSE MUSEUM, TISHOMINGO, OKLAHOMA.*

▶ SADDLE BACK RIDGE AT TISHOMINGO STATE PARK IN MISSISSIPPI.

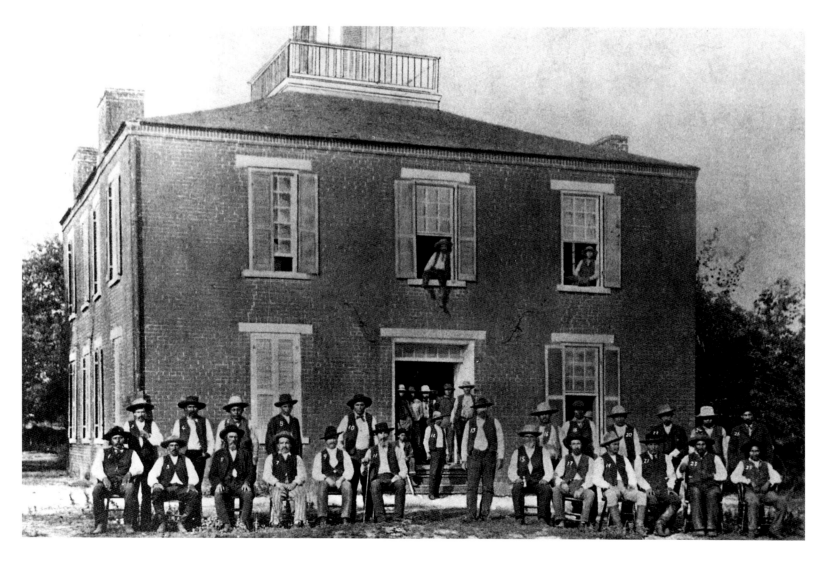

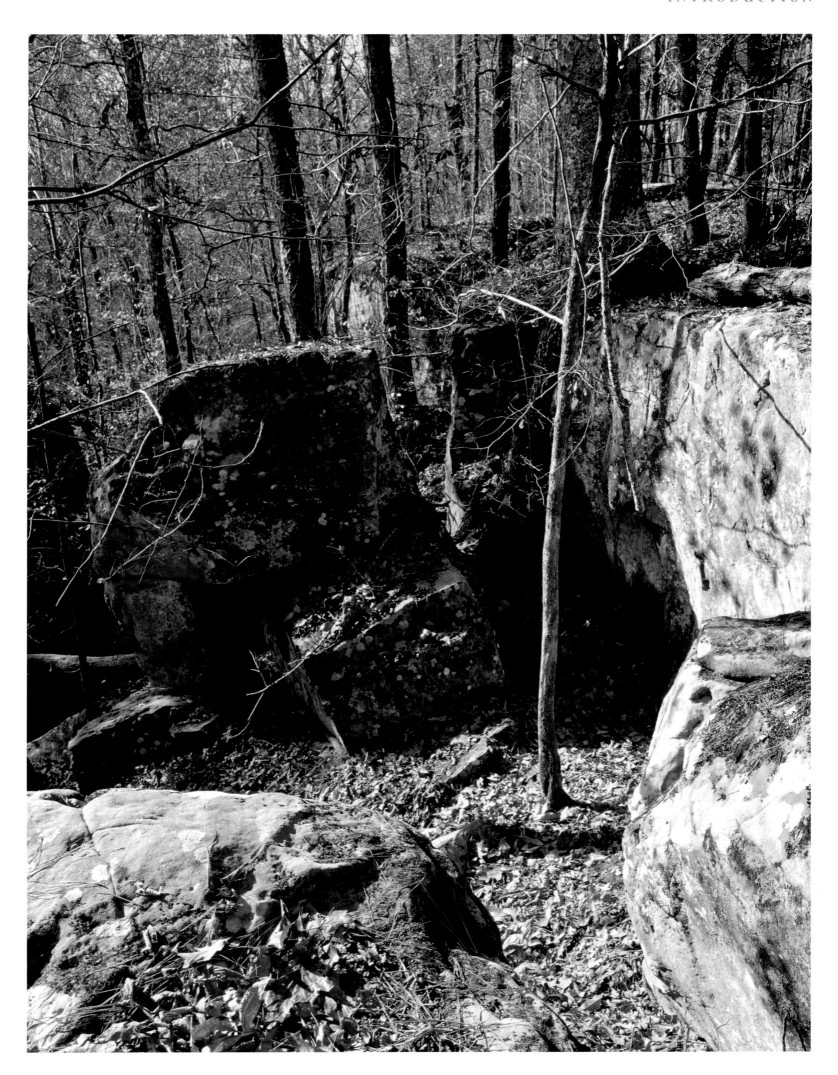

THE HOMELANDS

by Jeannie Barbour

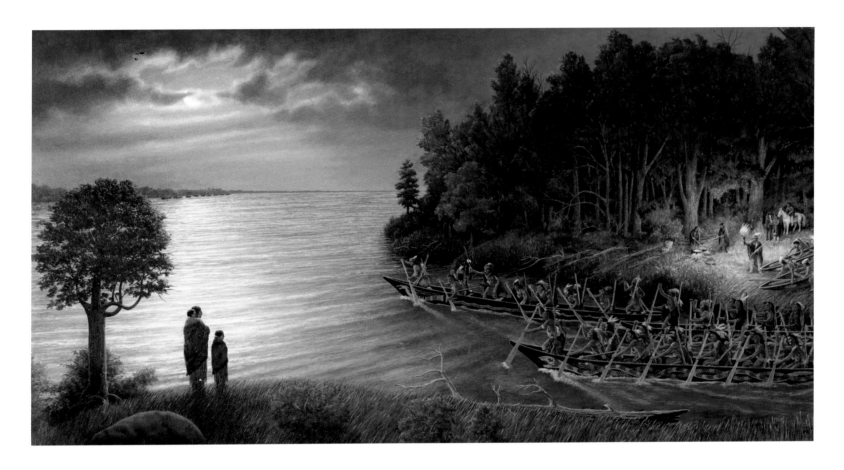

*It is the birthplace of the Chickasaw community
as we know it today and the resting place of its ancestors.
The original Tree of Life still grows somewhere there,
holding the world together with roots gripping
the earth and branches embracing the sky.*

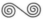

The homelands represent life to the *Chikashsha* people. It is the gift given by Ababinili after the great migration in ancient times. This covenant of land between the great composite force and the people he created is infused with spiritual meaning and blessed with physical beauty and abundance. It is the birthplace of the Chickasaw community as we know it today and the resting place of its ancestors. The original Tree of Life still grows somewhere there, holding the world together with roots gripping the earth and branches embracing the sky.

According to oral tradition, the Chickasaws' first settlements east of the Mississippi River were situated near the Tennessee River in Madison County, Alabama, at the original Chickasaw Old Fields. Later, the tribe would move to the headwaters of the Tombigbee River in the northeastern part of Mississippi. The settlements of Yaneka,

◄ MOUSETAIL LANDING ON THE
TENNESSEE RIVER.

▲ *CHICKASAWS DEFEND THEIR HOMELAND,
BLOCKADING THE MISSISSIPPI,* 1732–1763, BY
TOM PHILLIPS, CHICKASAW NATION PERMANENT
COLLECTION.

17

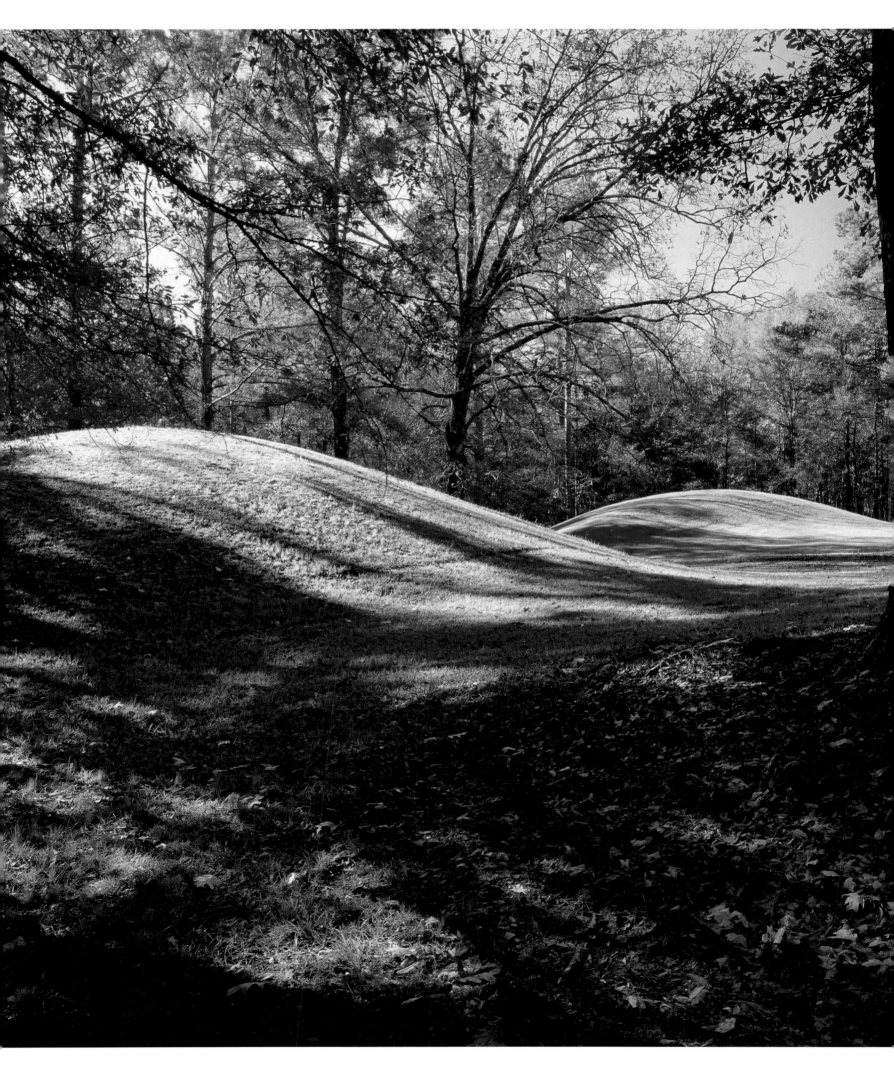

Shatara, Hikehah, and Chucalissa were scattered across the forests and prairies of the Tombigbee watershed. The tribal capital was Chukafalaya, otherwise known as Long Town by the British.

Early pioneer, Indian trader, and author James Adair lived with and wrote extensively about early Chickasaws and their homeland in his book *History of the American Indians*, published in 1775. Adair viewed the land with the same reverence as his Indian hosts, writing, "Lands of a loose black soil, such as those of the Mississippi, are covered with fine grass and herbage, and well shaded with large and high trees of

◄ BYNUM MOUNDS, BUILT BETWEEN 100 B.C. AND A.D. 200, LOCATED ALONG THE NATCHEZ TRACE PARKWAY, NEAR TUPELO, MISSISSIPPI.

▲ *War Canoe*, BY JAMES BLACKBURN.

▼ *CHICKASAW TRADE FAIR*, BY TOM PHILLLIPS, CHICKASAW NATION PERMANENT COLLECTION.

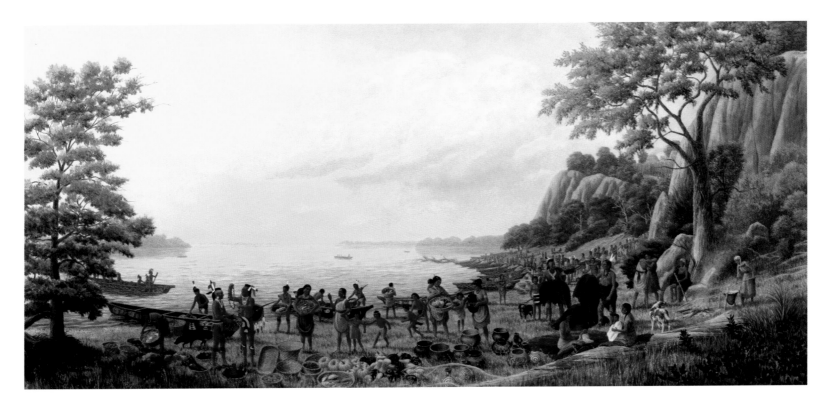

hickory, ash, white, red, and black oaks, great towering poplars, black walnut trees, sassafras, and vines. The low wet lands adjoining the rivers chiefly yield cypress trees, which are very large, and of a prodigious height. On the dry grounds are plenty of beach, maple, holly, and the cotton tree, with prodigious variety of other sorts."

Ababinili blessed the land with wild turkey, deer, bear, beaver, and all manner of wildlife to share with and sustain the Chickasaw people. Major waterways, such as the Mississippi, Tombigbee, and Tennessee Rivers fed by freshwater springs and tributaries, offered not only needed water, but trade and transportation within the region as well. The natural world shaped how Chickasaw people viewed themselves and their purpose. It had the power to provide life. Working together as a community in accordance with what nature taught assured survival of the community as a whole. Ababinili breathed life into all things within the homelands. Man and animal, plant and stone, all share that same breath.

Ababinili created his people striking in appearance. Early visitors to Chickasaw lands described the warriors as "tall, well-built people." The men possessed raven black hair and large dark eyes. The women were equally beautiful, with a musical lilt to their voices. Both men and women had a proud, independent demeanor and took great care in their dress and appearance. They decorated themselves with tattoo designs reflecting their personal sense of style and clan affiliation.

In prehistoric times, the old ones built great earthen temples, large ceremonial complexes, and agricultural fields that stretched for miles. Today we know these people as the Mound Builders. Their religion was based on knowledge of the sky and its celestial bodies. Their astonishing works of pottery art and shell adornments hold mysteries yet to be revealed. They, too, embraced the natural world, paying tribute to every aspect of its power and beauty. The gently sloping earthen mounds dotting the landscape throughout the homelands are a silent reminder of the old ones' architectural skill and ingenuity. The Spanish explorer Hernando de Soto and his company of conquistadors met up with the remnants of this great civilization in 1540. Although

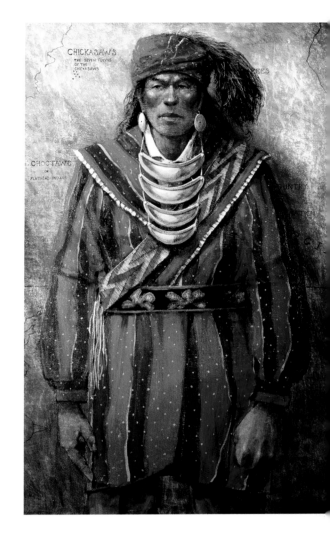

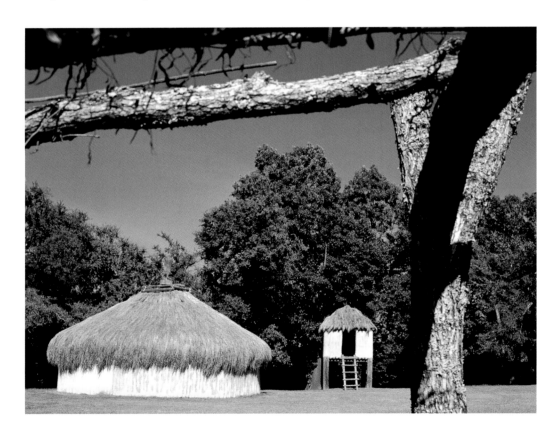

◄◄ BEAR CREEK IN TISHOMINGO STATE PARK, MISSISSIPPI.

▲ *TISHOMINGO*, BY MIKE LARSEN, CHICKASAW NATION PERMANENT COLLECTION.

◄ TRADITIONAL WINTER HOME AND CORN CRIB RECONSTRUCTION AT KULLIHOMA TRIBAL RESERVE NEAR ADA, OKLAHOMA.

▼ PIPE TOMAHAWK, MADE BY CHICKASAW BLACKSMITH CA. 1765, BELONGING TO A MEMBER OF THE KEMP FAMILY.

COLLECTION OF THE SMITHSONIAN CULTURAL RESOURCE CENTER, WASHINGTON, D.C.

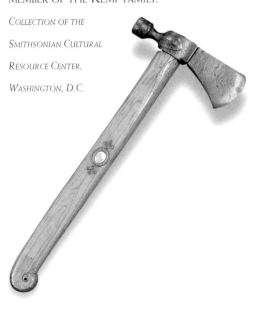

21

◄◄ Rock Creek in the Natchez
Trace Parkway.
◄ Old Natchez Trace.
▼ *The Chickasaw*, by Talmadge Davis,
Chickasaw Nation permanent collection.

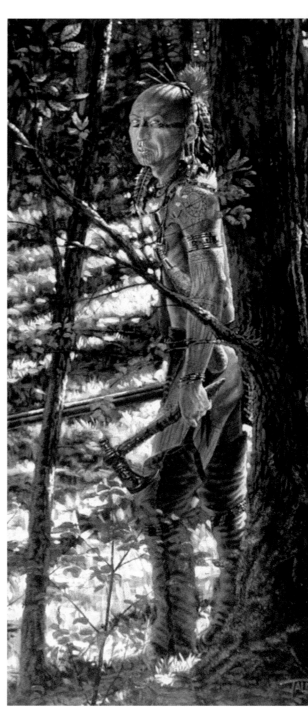

defeated and driven from the homelands, de Soto represented the beginning of
great change.

Chickasaws were known for their fierce warrior societies. The men were "swift of
foot" and commanded a strength and endurance unparalleled in the Southeast. During
times of war and ceremony, the men painted their faces. Ear spools and nose ornaments
were common adornments. White swan and turkey feathers fashioned into an elaborate
mantle were given to the most brave and noble of warriors. The women participated
in battles as well. They were expert in the fields of strategy and communications.
Every aspect of Chickasaw life was governed by martial tradition. Elaborate medicine
ceremonies were performed before each battle, with sacred bundles assembled for each
combatant. The only activity that might suspend hostilities for a time among the
Chickasaw would be that of trade.

An ever-enduring feature of the Chickasaw homelands is its numerous traces.
These nine-thousand-year-old lifelines wind back and forth across the length and
breadth of the old Chickasaw countryside. The most famous trace is the Natchez.
There were three Natchez Traces with different origins and purposes. The first was a
trail used by prehistoric Indians in their travels. Early habitation has been documented
at sites like Bynum Mounds, Pharr Mounds, and Cave Spring. Traders from the Ohio
Valley returning from expeditions to Spanish Louisiana created the second trail.
The third was a road built by the United States government to connect the towns
of Natchez and Nashville. The Natchez Trace was a bustling expressway for trade
activities, transportation, and military purposes. Chickasaw communities thrived along

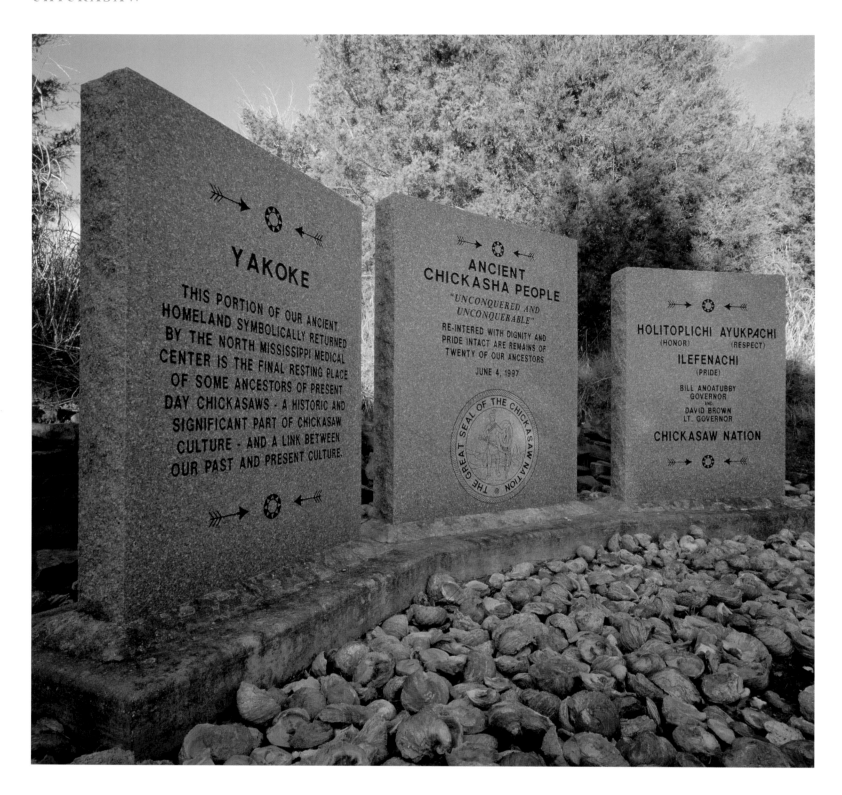

YAKOKE

THIS PORTION OF OUR ANCIENT HOMELAND SYMBOLICALLY RETURNED BY THE NORTH MISSISSIPPI MEDICAL CENTER IS THE FINAL RESTING PLACE OF SOME ANCESTORS OF PRESENT DAY CHICKASAWS - A HISTORIC AND SIGNIFICANT PART OF CHICKASAW CULTURE - AND A LINK BETWEEN OUR PAST AND PRESENT CULTURE.

ANCIENT CHICKASHA PEOPLE

"UNCONQUERED AND UNCONQUERABLE"

RE-INTERED WITH DIGNITY AND PRIDE INTACT ARE REMAINS OF TWENTY OF OUR ANCESTORS

JUNE 4, 1997

THE GREAT SEAL OF THE CHICKASAW NATION

HOLITOPLICHI AYUKPACHI
(HONOR) (RESPECT)

ILEFENACHI
(PRIDE)

BILL ANOATUBBY
GOVERNOR
AND
DAVID BROWN
LT. GOVERNOR

CHICKASAW NATION

▲ MEMORIAL TO THE ANCIENT CHICKASAWS IN TUPELO, MISSISSIPPI.

▶ SHILOH MOUNDS IN SHILOH NATIONAL MILITARY PARK NEAR SAVANNAH, TENNESSEE.

this route in the 1700s and 1800s. Events of great magnitude in Chickasaw history took place along the trace in locations such as Tockshish, Buzzard Roost Spring, and Colbert's Ferry.

The moccasin-clad feet of warriors such as Piomingo, Payamataha, and Tishomingo walked through the densely forested homelands with assurance bred from years of hunting and warfare. Of all the great leaders of the Chickasaws, these three held most fiercely to the old ways of nature and tradition.

In a time of great social change and upheaval, Chickasaws began to see their beloved homelands separated from them. Eventually this was accomplished in 1837 with the Treaty of Doaksville. Although most Chickasaws now reside in Oklahoma, their spiritual heart will always lie within the forested hills and gentle prairies of their southeastern homelands—their divine gift of life.

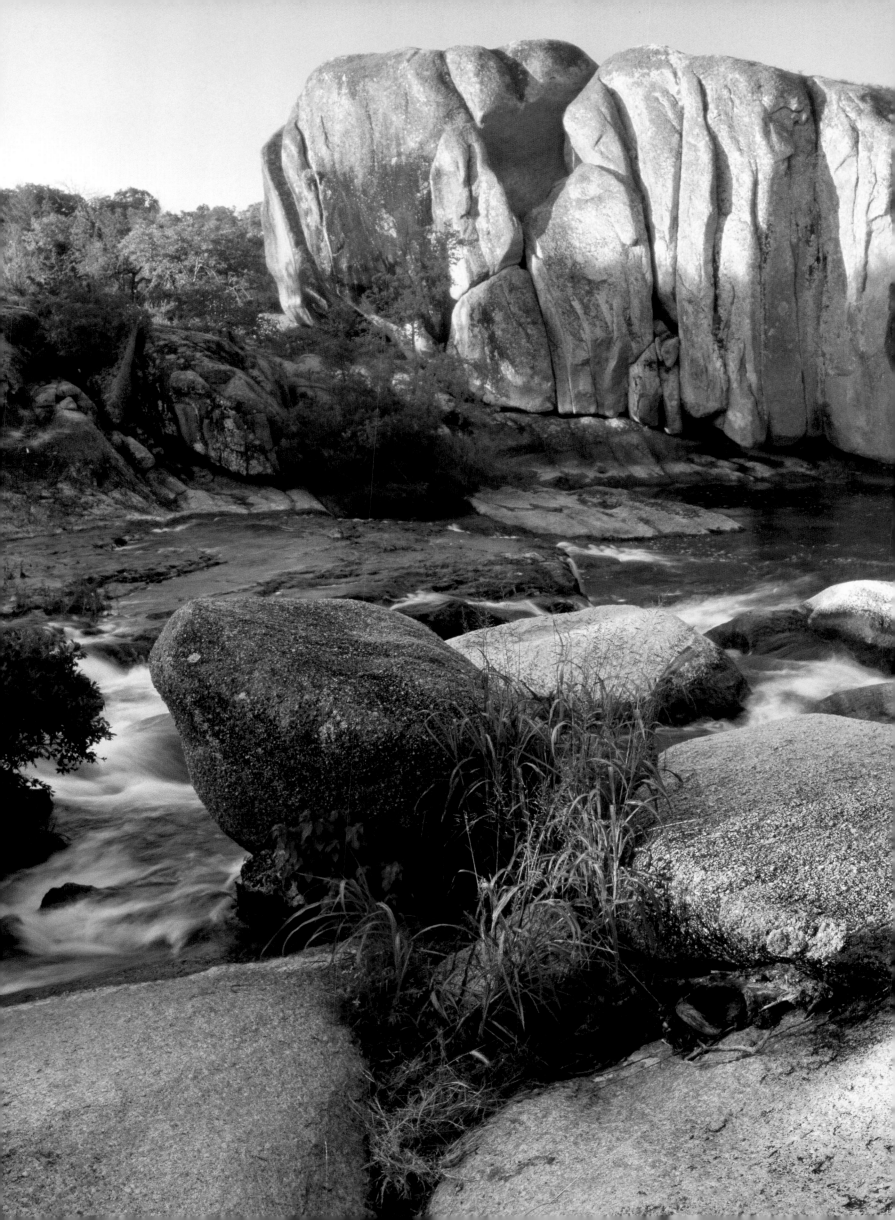

REBUILDING A NATION

by Jeannie Barbour

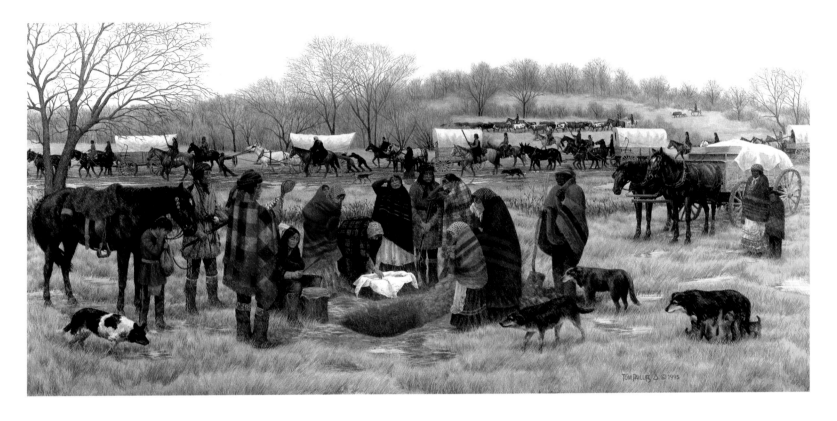

*But like the sacred fire, Chickasaws would not
allow themselves to be destroyed. Renewal in a new land would be
their mission, prosperity their ultimate goal.*

Removal was the saddest chapter in Chickasaw history. The process of emigrating from the homelands to Indian Territory lasted from 1837 until the 1850s. It is uncertain how many clans survived the treacherous crossing into Indian Territory. What is known through oral tradition is that they brought and tended their sacred fires smoldering in iron pots, waiting for the moment when the flames could be rekindled in new lands. Families met with hardship and death along their "Trail of Tears." If it had not been for the foresight and skilled negotiating practices of Chickasaw leaders, many more lives would have been lost. But like the sacred fire, Chickasaws would not allow themselves to be destroyed. Renewal in a new land would be their mission, prosperity their ultimate goal.

Indian Territory was considered a vast wilderness. The land within the Choctaw Nation that was set aside for the Chickasaw District by treaty was no exception. It encompassed the central and western portion of the Choctaws' vast land grant. The terrain was varied, with some of the richest soil in the United States. There were rolling prairies and hills, mountainous peaks rising over two thousand feet, and flat

◄ PENNINGTON CREEK IN JOHNSTON COUNTY, OKLAHOMA.

▲ *CHICKASAW REMOVAL*, BY TOM PHILLIPS, *CHICKASAW NATION PERMANENT COLLECTION.*

▼ BEADED SASH, COLLECTED IN THE EARLY TWENTIETH CENTURY. *COLLECTION OF THE SMITHSONIAN CULTURAL RESOURCE CENTER, WASHINGTON, D.C.*

lands where cypress and pine trees grew. In the spring and summer months, thunderstorms would boil up with such power as to produce large hail, spectacular lightning displays, and sheets of rain. Tornadoes were common as they created paths of destruction across the territory. Redbud, pecan, dogwood, walnut, elm, cottonwood, oak, hickory, and pine trees grew in abundance. There were extraordinary rock formations, bubbling springs, and cascading waterfalls. A profusion of rivers and creeks flowed from west to east.

Fishing and hunting was good in the new Chickasaw District. Although the bison were beginning to disappear by the mid 1800s, there were plenty of white-tailed deer, elk, black bear, antelope, beaver, rabbit, squirrel, and even some alligators. Chickasaws found bois d'arc trees to fashion their traditional bows and arrows. The creeks and rivers were home to a variety of fish and other wildlife. There was a great diversity of plant life. The eastern deciduous forest and the western prairies met in Chickasaw

▼ EARLY CHURCH MEMORABILIA, INCLUDING ARTICLES FROM THE COUNCIL HOUSE MUSEUM, TISHOMINGO, OKLAHOMA.

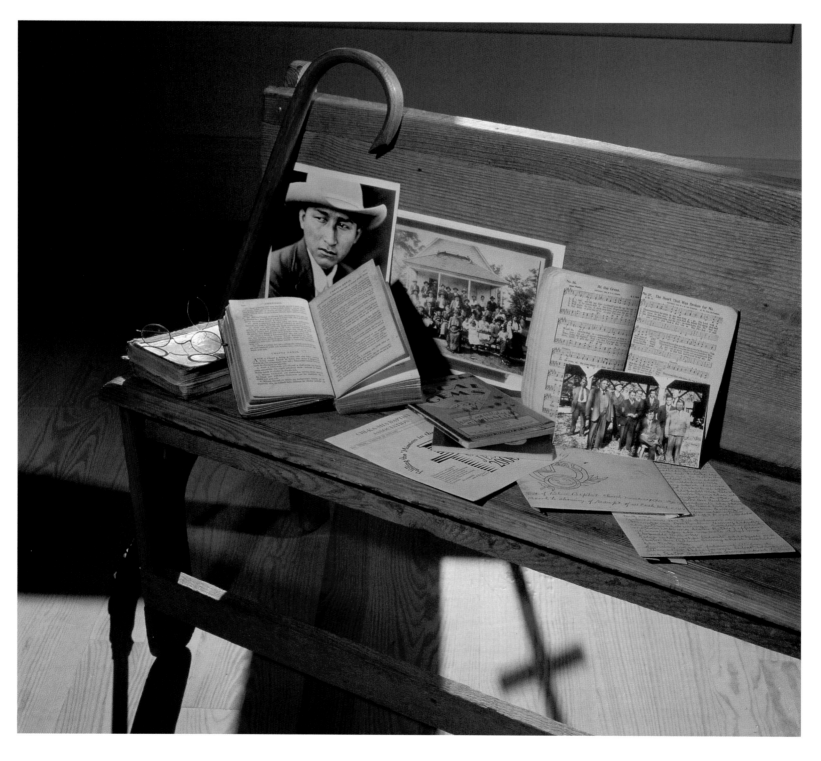

States appointed Chickasaw Nation governors. Douglas H. Johnston was the first man to serve in this capacity. He was the Chickasaws' appointed governor from 1906 until his death in 1939. He faced many difficult challenges in the first part of the twentieth century. It appeared the federal government had finally achieved its goal of absorbing the Chickasaw people into the national mainstream. However, Chickasaws continued to gather together socially in a belief that community involvement and support would sustain them. They spoke their language and continued to practice traditional activities whenever and wherever possible. Soon a grassroots movement began to take hold. Once again, Chickasaws demanded the right to govern themselves in a way that would benefit their people the most. As attention on civil rights issues gripped the rest of the country, a group of Chickasaws met at Seeley Chapel, a small country church near Connerville, Oklahoma, to work toward the reestablishment of their government. After the passing of Public Law 91-495, their dreams were realized. In 1971 the first tribal election since 1904 was held. Overton James was elected in a landslide vote.

Great change had come upon the Chickasaw people since their time in Indian Territory—even more since their time in the homelands. But throughout the turbulent years of the twentieth century, the Chickasaws sustained many of their core beliefs. Although their matrilineal society had all but disappeared, women still took their place as matriarchs within their families. Elder members of the tribe were still held in high regard for their knowledge and experience. Chickasaws still believed that sometimes war was necessary, and warriors stepped forth in defense of their country. They did so in WWI, WWII, the Korean conflict, Vietnam, and Desert Storm. Communities came together to support one another for the greater good. The natural world was still the great mystery deserving of respect and protection. And in the end, Ababinili was still the creator of all things good, including the Chickasaw people.

▼ Douglas H. Johnston home, known as the Chickasaw White House in Emet, Oklahoma, site of many important social and political events.

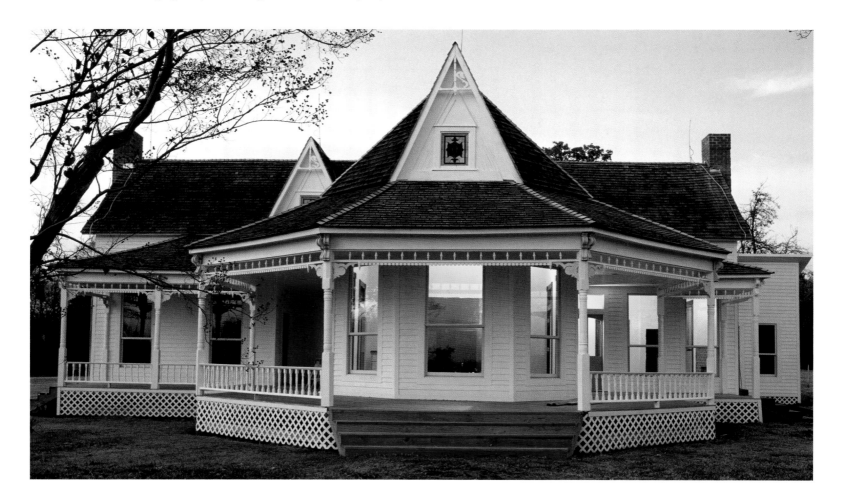

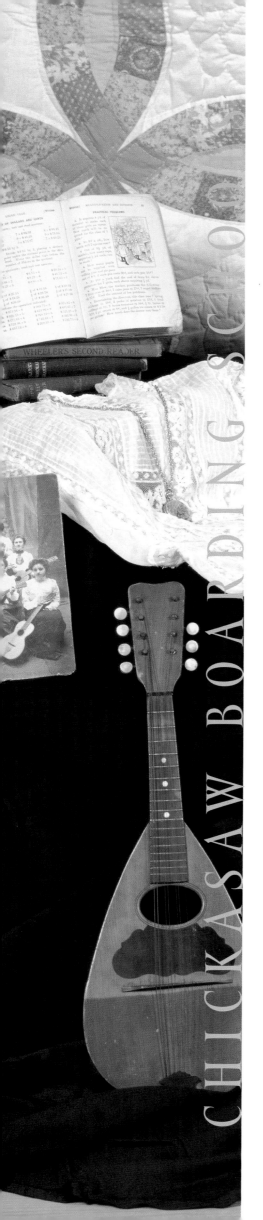

CHICKASAW BOARDING SCHOOLS
by Amanda Cobb

In spite of the devastation wrought by our forced removal to Indian Territory in 1837, Chickasaws determinedly rebuilt the nation. Knowing that education was crucial to our survival, Chickasaws founded a tribal academy, the Chickasaw Manual Labor Academy for Boys, in our first written laws in 1844. The Chickasaw Nation soon opened four other boarding schools for both males and females that include the Bloomfield Academy for Chickasaw Females, 1852; the Wapanucka Institute for Girls, 1852; the Collins Institute (Colbert), 1854; and the Burney Institute for Girls, 1859. Remarkably, these schools were founded by the Chickasaw Nation twenty years before the first federally run off-reservation boarding school, Carlisle, opened. Chickasaw schools represented a rare instance of tribal control during a time when most American Indian nations were defending their homelands and sovereignty through physical warfare with the United States.

The schools became the pride of the Chickasaw Nation. In the early years, Chickasaws partnered with Protestant denominations. Although the Chickasaw Nation supplied most of the funds, the missionary board controlled the schools' operation and hired the teachers from New England colleges and academies. The curriculum at the best-known of the Chickasaw boarding schools, the Bloomfield Academy for Girls, had academic, social, domestic, and religious components. Basic academic courses were offered, as well as instruction in "social graces" such as drawing, painting, and vocal music. The domestic curriculum included instruction in sewing, cooking, and housework, which missionaries considered an important part of the "civilization"

process. The religious curriculum, which consisted primarily of scripture memorization, was heavily emphasized as missionaries strove to replace Chickasaw traditions with Christian teachings. As part of that effort, the students were not allowed to speak the Chickasaw language at school.

The boarding schools closed briefly at the outbreak of the Civil War in 1861. After the war, the Chickasaws reopened boarding schools in 1876, this time without missionary help, and controlled the curriculum of the schools until Oklahoma statehood in 1907. During this period, which is known as the Golden Age of the Chickasaw boarding schools, Chickasaw leaders changed the curriculum of their schools. At Bloomfield, for example, the time spent on religious education was reduced and the academic curriculum was expanded. In fact, Bloomfield's curriculum was considered equal to that of a junior college. Students were instructed in social courses such as art, music, elocution, theater, and dancing. Domestic education was notably absent. Bloomfield enjoyed such a good reputation that the school was referred to as the "Bryn Mawr of the West," and students were known as the "Bloomfield Blossoms." The object of the curriculum was to educate students to become leaders, to participate in both Indian and white communities, and to help Chickasaws transcend significant social and economic boundaries.

The U.S. government began the process of taking control of the schools with the passage of the Curtis Act in 1898. At this time, the Chickasaw Nation operated thirteen day schools, four academies, and an orphan's home. By statehood in 1907, the government had laid the groundwork for a state educational system by using the schools of the "Five Civilized Tribes" as models. Government officials shut down all of the Chickasaw schools except Bloomfield Academy. Bloomfield remained in operation until 1949, but out of direct Chickasaw control. In spite of this, Bloomfield, renamed Carter Seminary in 1932, continued to be closely associated with the Chickasaw Nation and its families and values. Many alumni of the Chickasaw schools did indeed become the community leaders the nation had hoped they would become, and generations of Chickasaws have benefited from education, traditions, and pride instilled in them by these graduates.

◄ AND ► HISTORIC ARTICLES FROM THE BLOOMFIELD ACADEMY FOR GIRLS ORIGINALLY LOCATED NEAR ACHILLE, OKLAHOMA IN 1848, AND LATER MOVED TO ARDMORE, OKLAHOMA, IN 1906.
◄ FORMER BLOOMFIELD STUDENTS, SOPHIA PERRY, ETNA COOKE, PAULINE ADKINS, AND LILLIE WARD.
▼ BLOOMFIELD ACADEMY, CA. 1860, NEAR ACHILLE, OKLAHOMA.

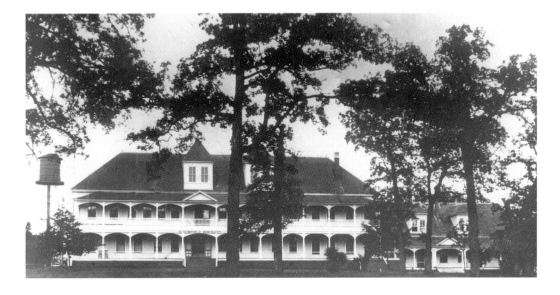

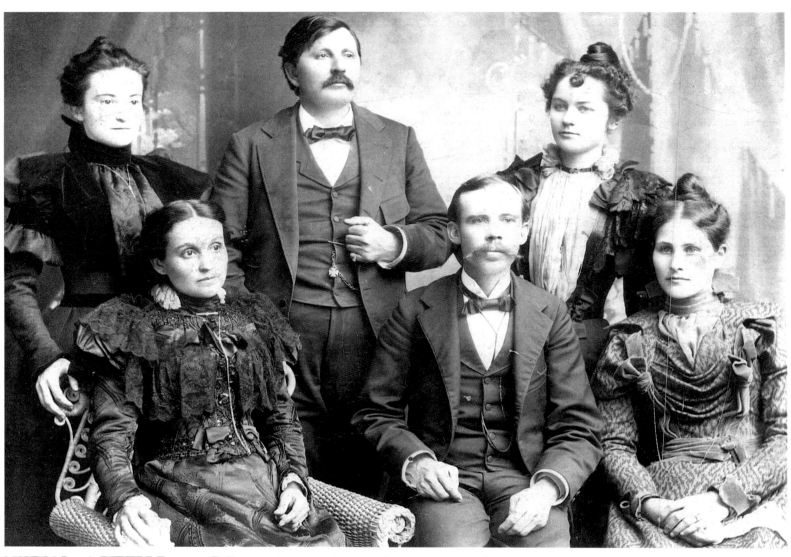

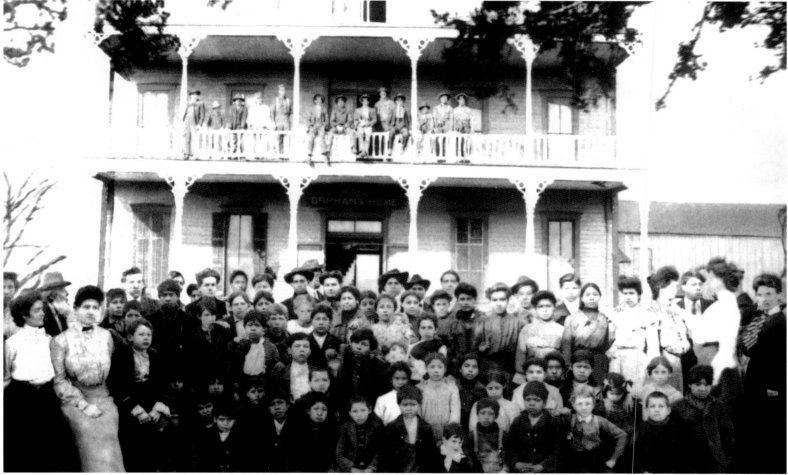

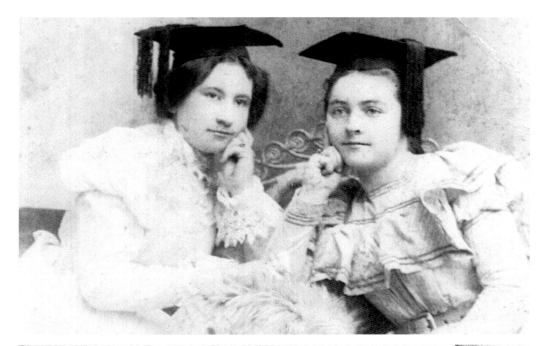

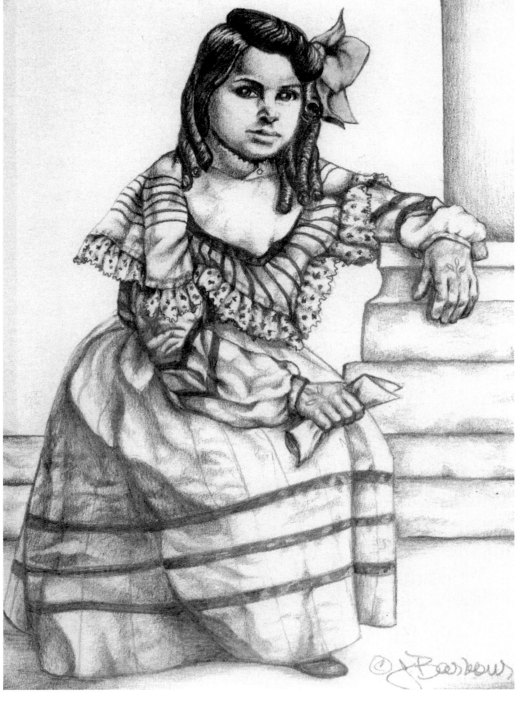

◄▲ DOUGLAS H. JOHNSTON PICTURED WITH BLOOMFIELD FACULTY IN LATE 1800s INCLUDING HIS NIECE, ALICE HEARRELL (FIRST ROW, FAR RIGHT), WHO LATER BECAME MRS. ALFALFA BILL MURRAY.

◄◄ BURNEY INSTITUTE, ALSO KNOWN AS CHICKASAW ORPHANS HOME, LOCATED EAST OF LEBANON, OKLAHOMA, CA. 1892.

▲ BLOOMFIELD GRADUATES, CA. 1900.

◄ *BECKY AT THE BALL*, BY JEANNIE BARBOUR, OKLAHOMA SUPREME COURT JUSTICE YVONNE KAUGER COLLECTION.

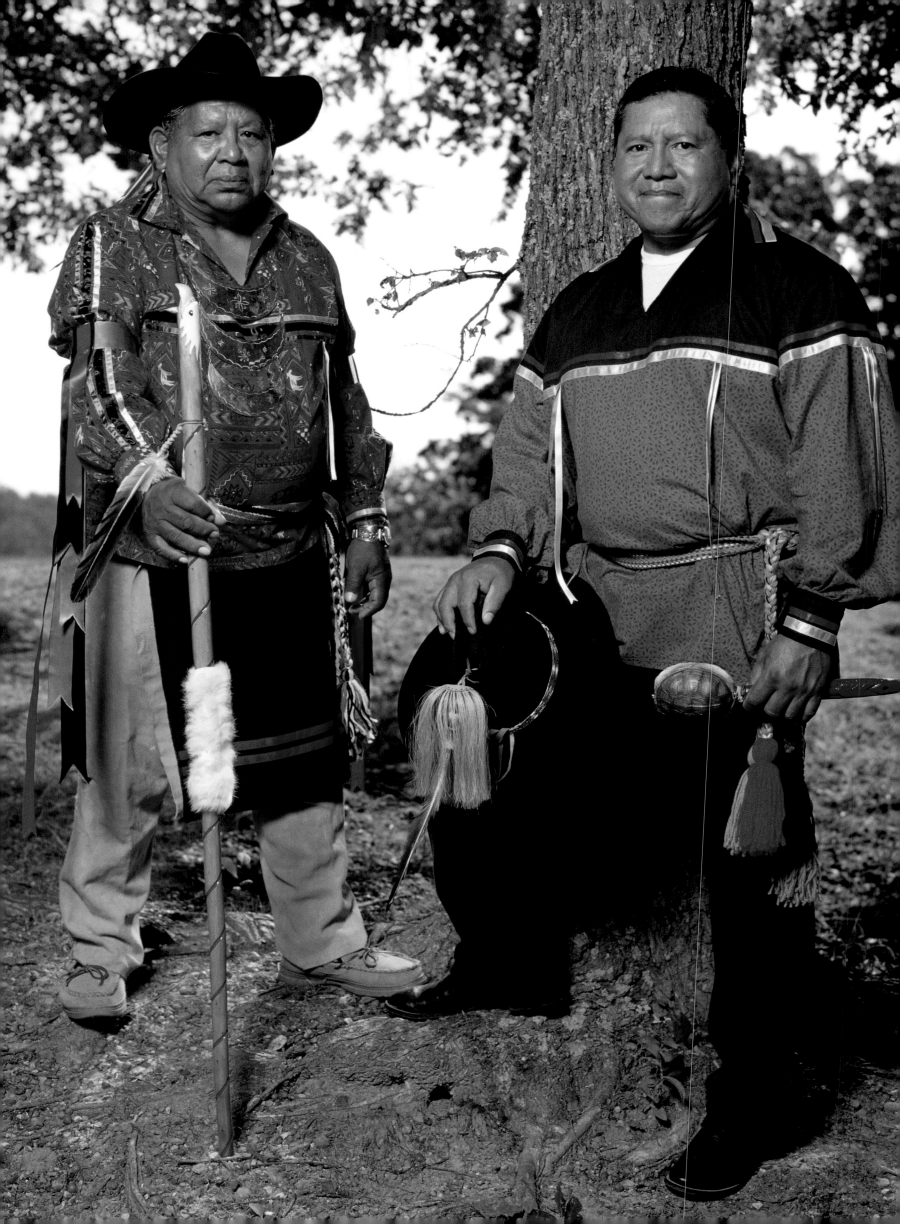

OUR FIRE

by Jeannie Barbour

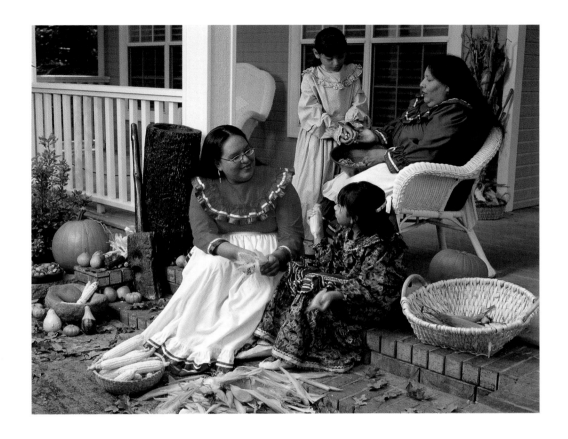

*For traditional Chickasaws, there is no death, only another step
in the spiritual journey that is life. The sacred fire used for stomp dance
symbolizes this belief in constant renewal. Like life itself, it is impossible to kill
the sacred fire. Its energy can be transformed or transferred but never
fully extinguished. Much power is inherent in the fire.*

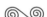

Chickasaws are a people of resilience who possess a deep sense of spirituality. Our complex relationship with the natural world defines who we are and where we are going through the cyclical rhythms of a living universe. There is a profound understanding among our traditional people of the interrelatedness of all things in this world. The beginning and the ending of us are always with the earth.

Chickasaw culture is distinctive and reflects its Muscogean roots in its spiritual, material, intellectual, and traditional beliefs. Chickasaw traditionalists believe one can never truly know oneself without intimate knowledge of one's own culture—no matter what that culture may be. Cultural identity is the root of who we are as a nation and is fundamental for every activity in which we are involved. A person cannot travel the journey of life without first understanding where he or she has come from or why he or she is moving forward.

◄◄ CULTURE BEARERS AND STOMP DANCE
LEADERS LEERENE FRAZIER (LEFT) AND
HASKELL ALEXANDER (RIGHT).
◄ PREPARING TRADITIONAL CHICKASAW
FOODS OF CORN AND BEANS ARE SHELLY WALL,
COURTNEY JOHNSON, GEORGIE GREENWOOD
FRAZIER, AND RENEE JOHNSON.
▼ BEAR EFFIGY POT, BY JOANNA UNDERWOOD,
COURTESY OF THE UNDERWOOD COLLECTION.

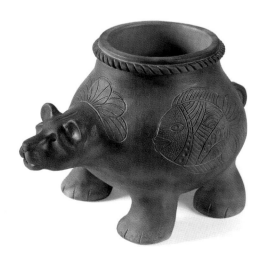

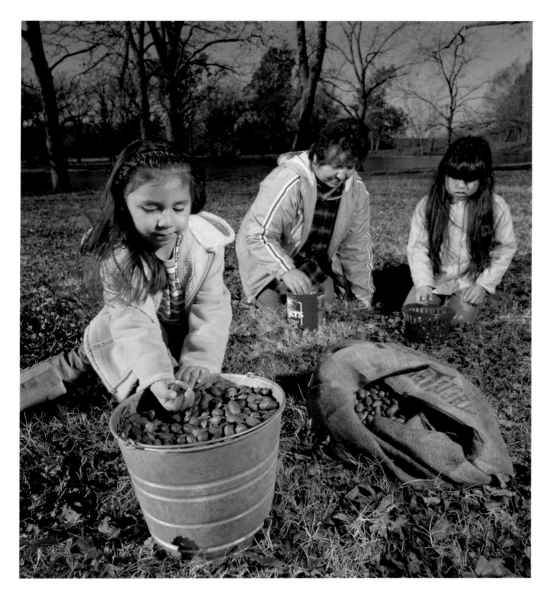

◄◄ TRADITIONAL FALL FARE OF PUMPKIN
BREAD, PERSIMMON COOKIES, PECANS,
SQUASHES, AND PEARS WITH CULTURAL ITEMS.
◄ CAITLYNN SPARLIN, SUZANNE RUSSELL, AND
RAVEN CARNEY GATHER AUTUMN PECANS.
▼ POSSUM GRAPES ARE GATHERED IN THE FALL
TO MAKE A CHICKASAW FAVORITE, POSSUM
GRAPE DUMPLINGS.

▼ TRADITIONAL PASHOFA PADDLES AND
SPOONS, COLLECTED EARLY IN THE TWENTIETH
CENTURY. *COLLECTION OF THE SMITHSONIAN CULTURAL
RESOURCE CENTER, WASHINGTON, D.C.*

Chickasaws come from the homelands, located in the southeastern states of Alabama, Mississippi, Kentucky, and Tennessee. They are the spiritual heart of our nation and a sacred gift given by Ababinili. The lands held the promise of prosperity after the long migration journey of our ancestors. In return we cared for the earth, never taking more than what was needed for survival and respecting every living thing. This commitment to good stewardship was in the belief that by protecting the natural world, we in turn would be protected and given balance there.

All human relationships were infused with nature. Family units were symbolized by clan associations with the eagle, panther, buffalo, deer, raccoon, tortoise, snake, fish, and fox; and likewise, of the wind, sky, water, fire, and earth. At the moment of birth male and female roles were very clearly defined. Although blood ties were shared, we as a people also had a long-standing tradition of the adoption of others into families and communities. All were cared for equally and all were given specific social, political, and religious privileges, duties, and rights under the law. These elements of cultural responsibility and advantages tied people together.

One of the most important duties established by each clan was the raising, gathering, and hunting of food. Women played a major role by owning and maintaining the vast agricultural fields of corn, beans, and squash. They were also the primary gatherers of food sources from the wild—onions, grapes, plums, nuts, and berries. Expert in the varied arts of hunting and fishing, Chickasaw men would travel many miles in

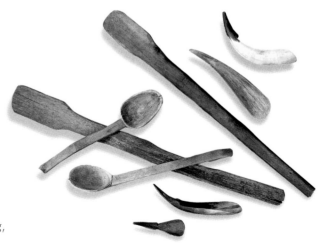

41

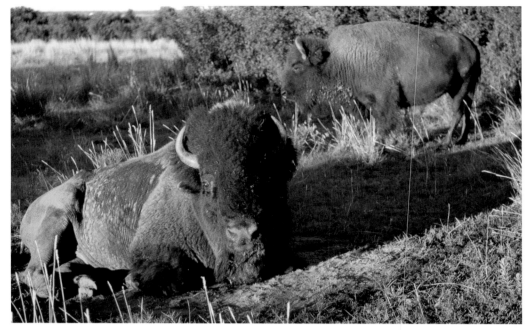

▼ HUNTING TOOLS OF HATCHETS, BOW AND ARROWS, AND BLOW DARTS, COLLECTED IN THE EARLY TWENTIETH CENTURY. *COLLECTION OF THE SMITHSONIAN CULTURAL RESOURCE CENTER, WASHINGTON, D.C.*

▶ BISON IN SULPHUR, OKLAHOMA.

▶▼ HISTORIC CORN GRINDING ROCK AT TISHOMINGO STATE PARK, MISSISSIPPI.

▶▶ MORGAN WELLS PROUDLY DISPLAYS CORN GROWN FROM THE SEEDS BROUGHT TO OKLAHOMA FROM THE HOMELANDS BY HIS FAMILY DURING REMOVAL.

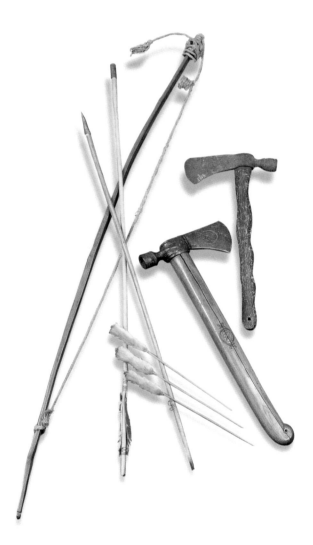

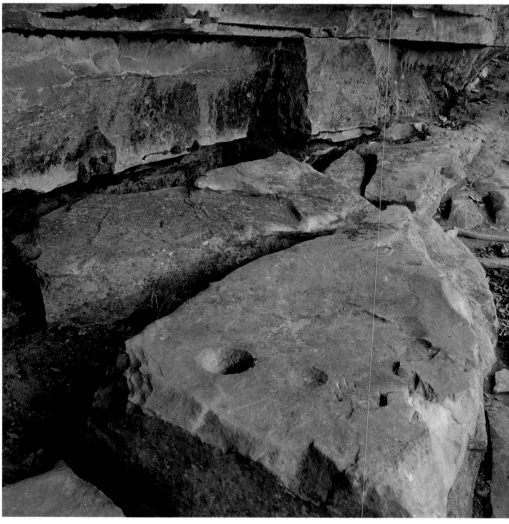

pursuit of game. All food gathered was shared equally with one another and the "Great Composite Force." Our relationship with the earth and its fruits could not be separated from the spiritual.

One of the most important foods to the Chickasaws' cultural identity was and still is pashofa. This soupy corn dish has held great significance in religious and social activities for many hundreds of years. For generations Chickasaw mothers have shared time-honored recipes and stories of pashofa with their daughters.

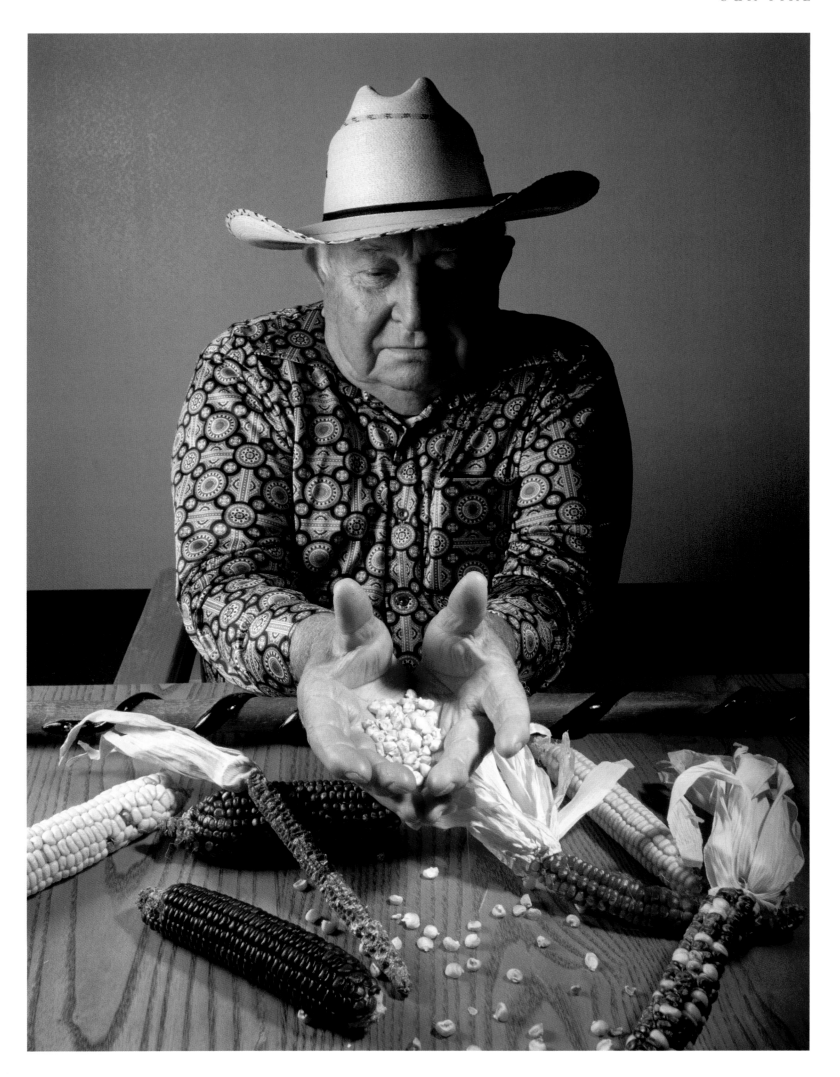

▼ THE BOIS D'ARC TREE IS STILL USED TODAY FOR MAKING BOWS, DYES, AND OTHER CULTURAL ITEMS.

▶ KNIVES MADE BY DANIEL WORCESTER.

▼▼ TRADITIONAL STICKBALL STICKS MADE FROM PECAN AND HICKORY BY CHICKASAW FATHER AND SON, MARTIN STICK SR. AND MARTIN STICK JR. THESE STICKS WERE MADE BY USING ONLY A KNIFE AND HATCHET TO SHAPE THE WOOD AND ARE UNIQUE IN THE WAY THE HANDLES ARE FASHIONED AND TIED.

In this quiet familial way, a piece of Chickasaw tradition has been sustained in the face of tremendous cultural change.

Pashofa's greatest contribution was that of healing the gravely ill. Traditional belief attributes many serious illnesses to unforgiving or offended animal spirits and other unpleasant elements of nature that may have somehow invaded a person's body. This

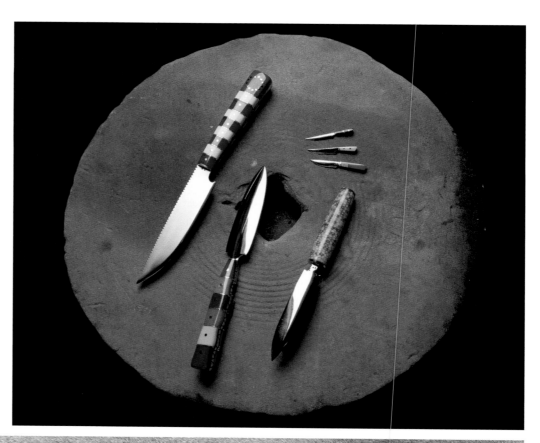

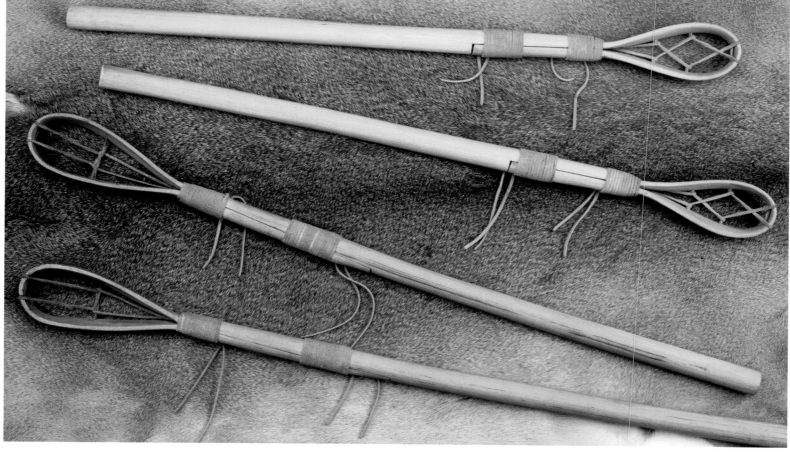

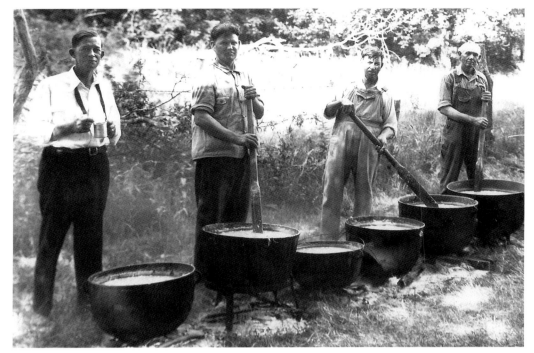

◄ Cooking pashofa in the early 1900s.
Courtesy of the Chickasaw Council House Museum, Tishomingo, Oklahoma.

▼ Siblings of the Shields family prepare pashofa, a traditional Chickasaw dish. Pictured from left are Mary Gipson, Mae Hamilton, Gayle Shields Clark, Carol Fox, Louise Shields, and Charles Shields.

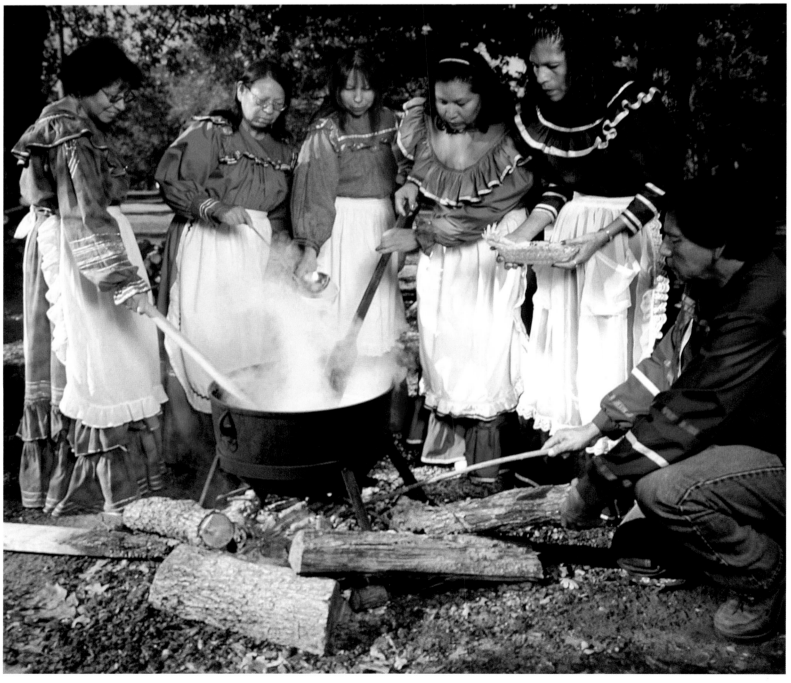

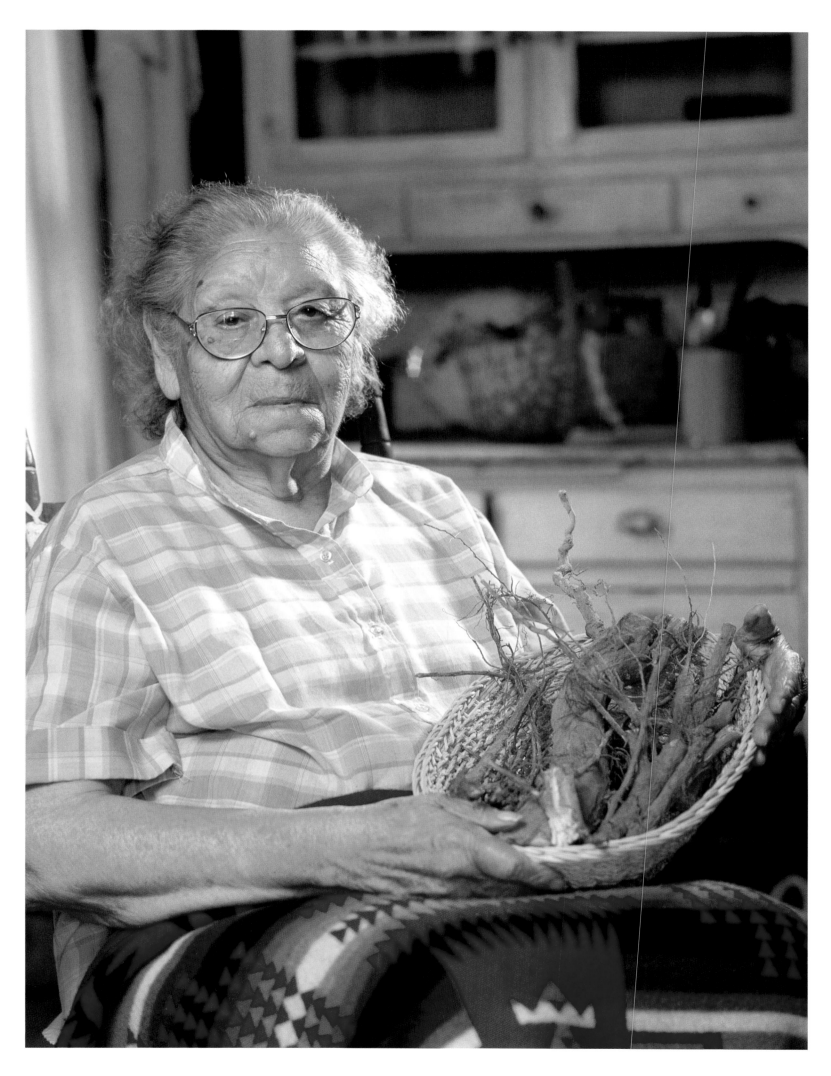

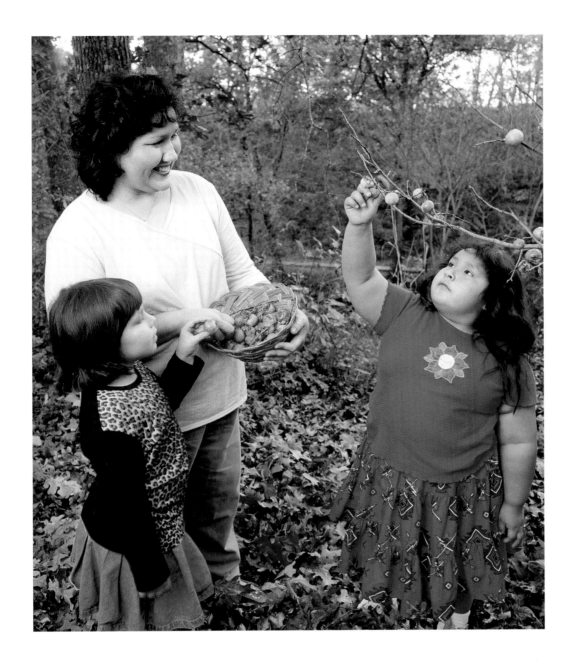

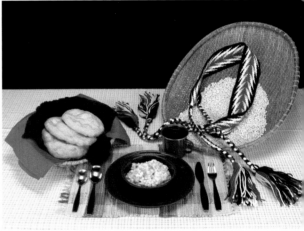

became more prevalent over time as European culture entered Chickasaw lifeways and the earth was used without respect to its needs. The pashofa ceremony brought the afflicted person's family together in an act of sacrifice and love to heal with the help of an aliktce (Chickasaw medicine man) and the eating of pashofa.

Of course, there are many plants in the Chickasaw healing arsenal. In early times, every family was well versed in the uses of herbs and plants made available by Ababinili to cure illnesses and prevent disease. Understanding the rhythms of nature and the changing of the seasons was critical. Common weeds to the untrained eye, Chickasaw healers recognized them for their great value. Expert in skills of harvesting to the highest potential, care was taken never to collect beyond the limits of what flora needed to reproduce the next year.

Ailments of a spiritual nature, however, required healing practices of a different level of expertise. Medicine men and herbal women spent a lifetime gaining the wisdom and required skills necessary for their calling. Procedures performed on seriously ill persons included not only elements from nature, but also the use of prayers, chants, and songs in the Chickasaw language.

According to strictest Chickasaw belief only men selected by the Iyaganashas, or Little People, as young children were qualified to practice the good medicine

◄◄ CHICKASAW ELDER AND CULTURAL PRESERVATIONIST MINNIE SHIELDS WITH SASSAFRAS ROOTS.
▲◄ REBECCA ORPHAN, SKYLA ORPHAN, AND HARMONY FOLSOM PICKING PERSIMMONS.
▲ PASHOFA, MADE FROM WHITE CRACKED CORN, IS A TRADITIONAL CHICKASAW DISH.
PHOTO BY MATT BRADBURY

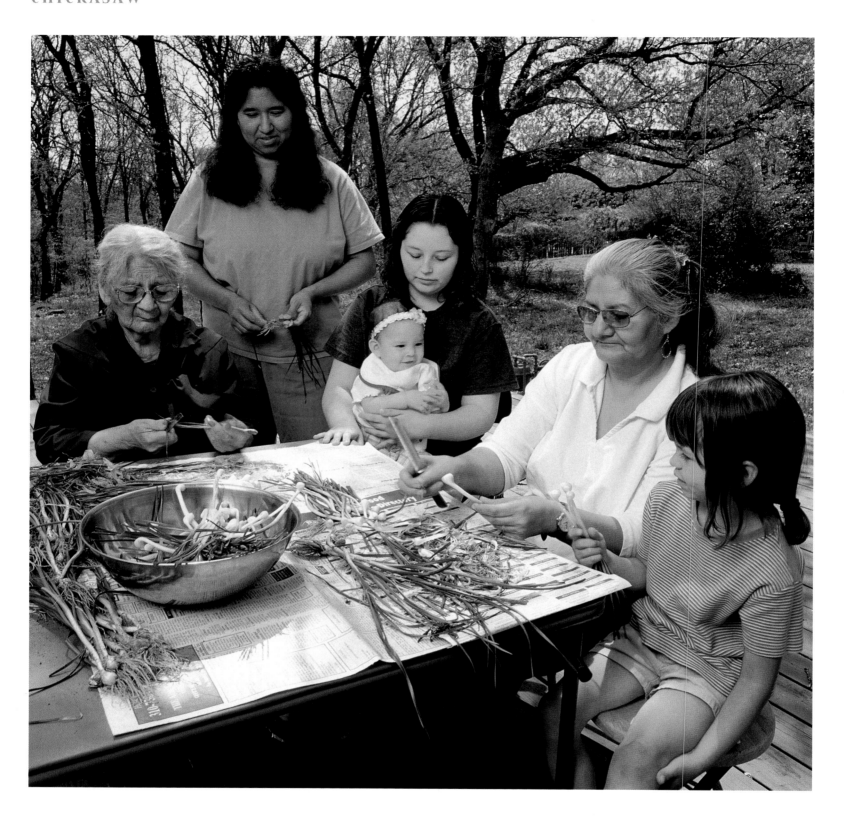

▲ WILD ONIONS, CORN BREAD, AND SALT
PORK ARE A FAVORITE TRADITIONAL MEAL
AMONG CHICKASAWS. CLEANING WILD
ONIONS ARE LYDIA KILCREASE, DINAH
WORCESTER, JULIA WORCESTER HOLDING
ABAGALE JACKSON, ROSETTA WORCESTER,
AND HEAVEN PARKS.

required to heal spiritually ailing individuals. Those who sought the knowledge to heal in a spiritual way through other means were doomed to fail in their pursuits, and quite often were corrupted by the darker arts of witchcraft and bad medicine.

The power of Chickasaw words was not only used for medicinal purposes but in every facet of life. The complexity of Chickasaw cultural practice and its distinctive worldview is defined through its language. Tribal and familial relations, unique and elusive human thought, as well as expressions of song and oral tradition, are found within Chickasaw words. In short, without language, there is no Chickasaw culture. The keepers of our words today are, for the most part, over the age of fifty. Unfortunately, like many other Native American tribes in North America, Chickasaws are rapidly losing their language to the ravages of modern technology and Western culture. Recognizing

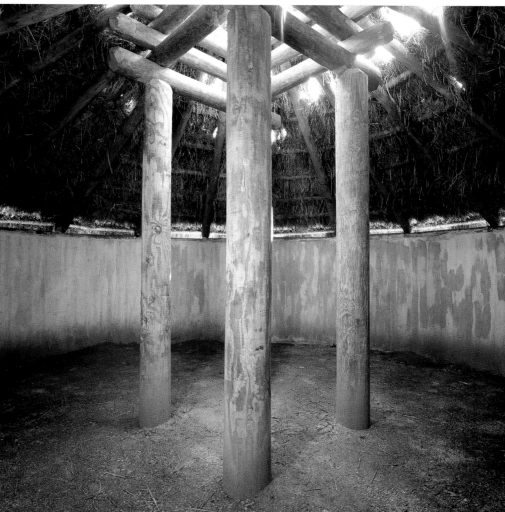

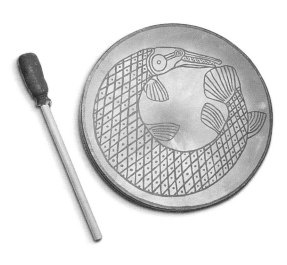

◄◄ Te Ata Thompson Fisher, famous storyteller and actress, ca. 1930, named Oklahoma's first State Treasure in 1987.
◄ *The Storyteller*, by Jeannie Barbour, *Galvan Family Collection*.
▼ Winter house at Kullihoma, Oklahoma.
▼► Hand drum for nani kallo hilha' (Garfish Dance), by Joshua Hinson.

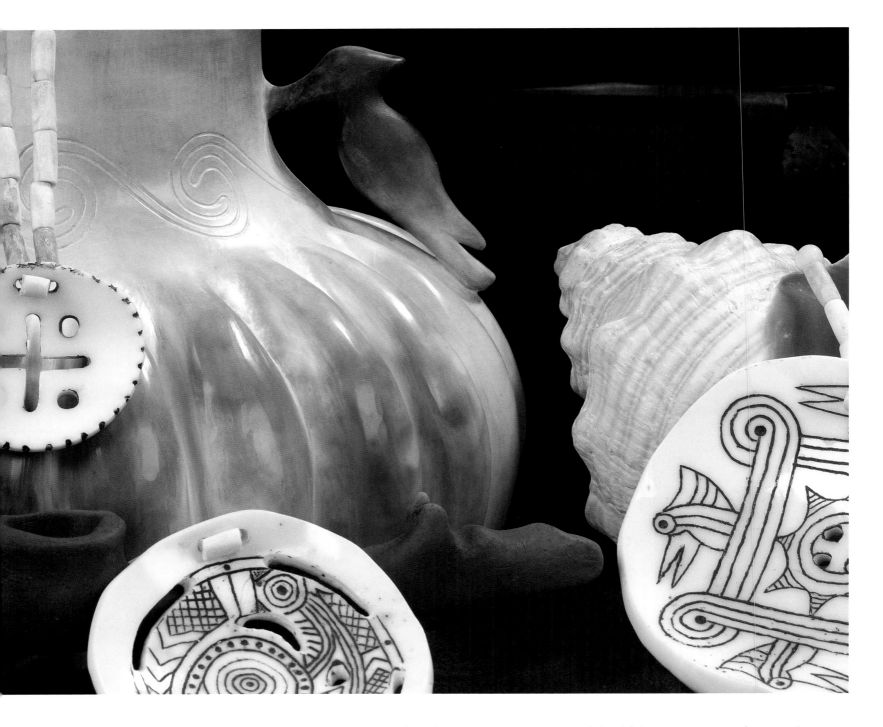

▲ CONTEMPORARY CHICKASAW ARTISTS
HONOR THEIR ANCESTORS BY CREATING WORKS
THAT ENSURE ONGOING CONTINUITY BETWEEN
OUR ANCIENT PAST AND OUR LIVING CULTURE.
POTTERY BY JOANNA UNDERWOOD AND SHELL
GORGETS BY JOSHUA HINSON. *PHOTO COURTESY OF
KONRAD EEK*

▶ LITTLE NIAGARA AT THE CHICKASAW
NATIONAL RECREATION AREA IN SULPHUR,
OKLAHOMA.

births, deaths, religious events, moments of thankfulness, occasions of war, and
milestones of great importance. Chickasaw dance and song are best considered as
prayers in the celebration of life—with stomp dance at the very center. Most Chickasaw
dancing took place outside in the open air and was commonly held during social
occasions. The community catching of fish and subsequent fry was a popular event for
dance and song. After hunger was satisfied, tribal members young and old came
together to shake shells, sing, and dance counterclockwise around a consecrated fire.
Ancient steps with names such as the ball game, green corn, buffalo, and four corners
were performed with ancient knowledge passed down through countless generations.
These events lasted until the small hours of the morning and bonded a community
together through shared fellowship.

Since the time of our Woodland ancestors, Chickasaws have been expressing their
spiritual, political, social, ceremonial, and commercial identity through visual art.
Many of the tribe's most priceless assets lie within collections of burial art objects
excavated over time from the earth of the homelands. Thousands of pieces of sacred

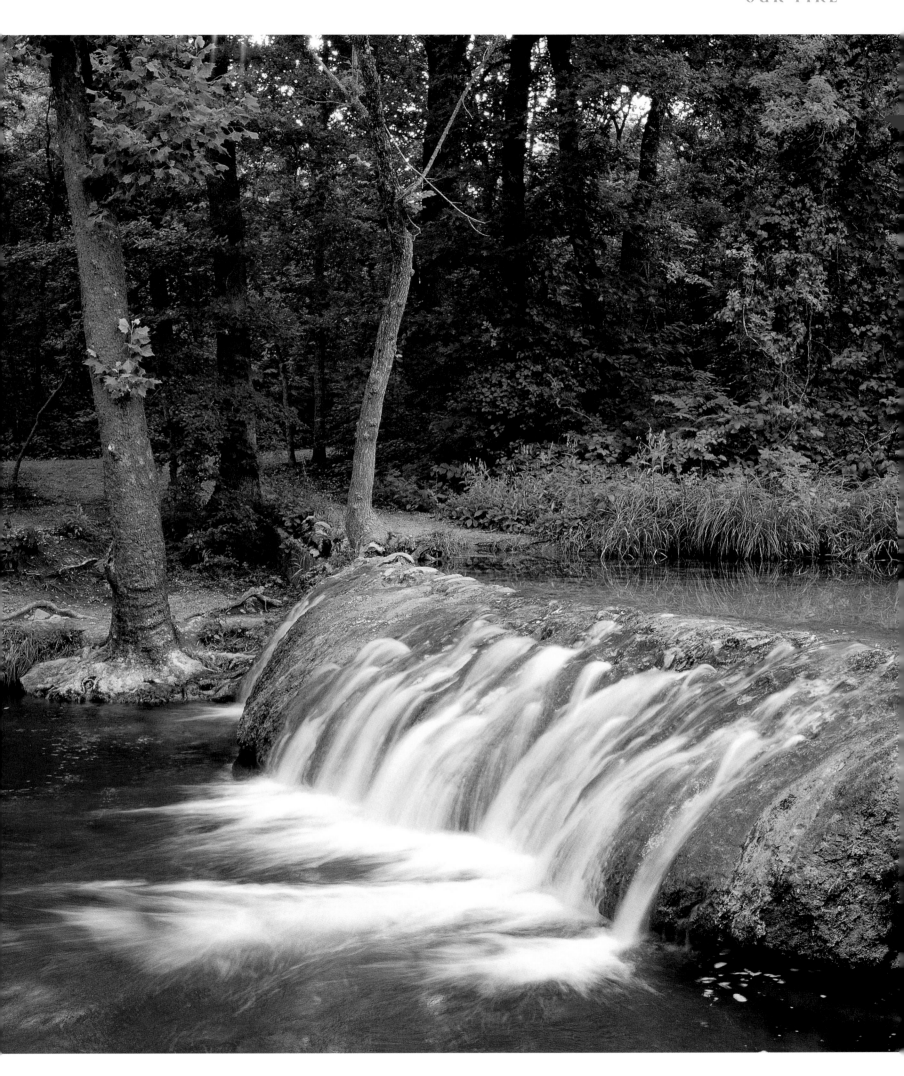

CHICKASAW

▼ THE CHICKASAW NATION DANCE TROUPE, ESTABLISHED IN 1992, CONTINUES THE CHICKASAW STOMP AND SOCIAL DANCE TRADITIONS.

prehistoric pottery, tools, weapons, pipes, and ceremonial items wait to be repatriated from museums and other facilities across the country through the Native American Graves Protection and Repatriation Act (NAGPRA). Those Chickasaws fortunate enough to view these precious objects made by their ancestors' hands have described

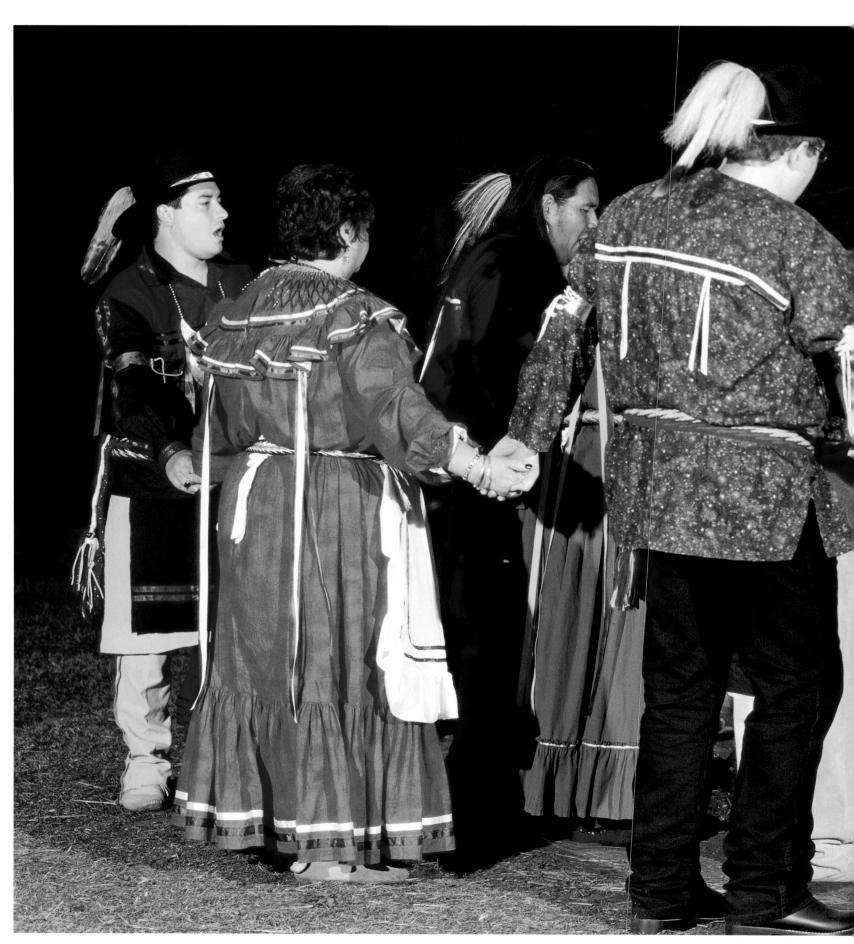

a great sense of awe and reverence. It has been said that art is a testimony to existence. It has never been more true than for that of today's Chickasaw artists. They bring together elements of their cultural past with conditions of the present, ensuring the continued expression of Chickasaw art for generations to come.

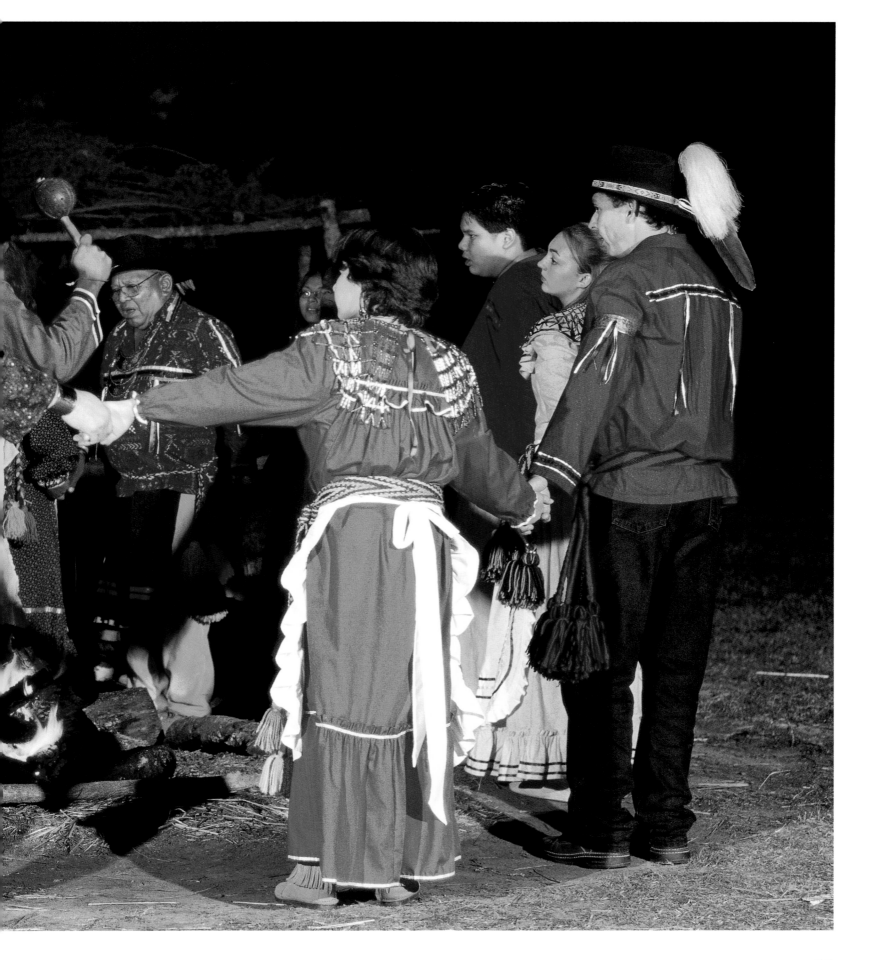

"TIGER PEOPLE"

by Geary Hobson

1.

*Lying along the wide branch
in a fist of gathered tension,
the panther waits, watching her prey.*

*When the panther springs,
you will see such a motion
of fluid grace—like blinding lightning
framed in frozen rock.*

*The cubs watch their mother,
eyes wide with love and awe—
by her example they will learn
grace and beauty
and how to survive in a hostile world.*

2.

I make it down to the stomp-dance grounds

early

*in the back of a beat-up pickup,
two men and a woman quietly sing
Muskogee songs, and check the turtle-shell*

rattles

before the dancing begins.

*There is such calm-enshrouded tension,
betrayed only by the motion of expectant eyes.
It is going to be a good dance.*

Although much of Chickasaw identity lies in the foundation of our cultural past, Chickasaw people have always looked to the future. For traditional Chickasaws, there is no death, only another step in the spiritual journey that is life. The sacred fire used for stomp dance symbolizes this belief in constant renewal. In times past, Chickasaws believed fire provided life through warmth and utilitarian needs. All used the fire during stomp dances to send prayers through the smoke to Ababinili. Because of this, great care was taken in starting, maintaining, and renewing the flames annually. The keepers of the sacred fire were the holiest members of a tribal town. These people carefully preserved the fire on the long journey from the homelands to Indian Territory during removal in the mid 1800s. Like life itself, it is impossible to kill the sacred fire. Its energy can be transformed or transferred but never fully extinguished. Much power is inherent in the fire. Today, nearly all Chickasaw holy fires lie sleeping in carefully concealed locations throughout the Chickasaw Nation.

Like the sacred fire, for a great number of Chickasaws their culture lies sleeping in their hearts, waiting for the day when its power is reignited. This can only be accomplished through exposure to all the elements that make up Chickasaw culture. It is not an easy process. Those committed to the search for true identity will be rewarded. Ababinili reveals the great mystery of what it means to be Chickasaw in his own time and in his own way. It is a journey never ending—like the seasons, ever changing with life renewed.

◄ *STOMP DANCER*, BY BRENT GREENWOOD.

▲ STOMP DANCE VEST BY JEAN BILLEY, BELT BY TIM HARJO, AND BEADED HATBAND BY RANDY SHACKLEFORD. *PHOTO COURTESY OF KONRAD EEK*

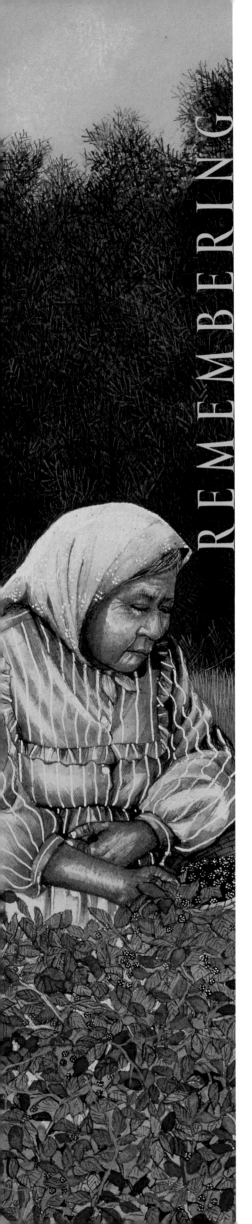

REMEMBERING
by Linda Hogan

Coming from the Mound Builders, the brilliant calculators of time who stretched their hands in reverence toward the new moon, granddaughter and daughter of tribal leaders, she was born in 1883.

Like all Chickasaw girls, my grandmother Lucy was a student at Bloomfield Academy, an Indian girls' school started by missionaries in Indian Territory with the purpose of Americanizing the girls. I found her graduation exercises in the *Chronicles of Oklahoma*. She played a piano solo at commencement. Her sister recited "The Lotus Eaters" by Tennyson. The Reverend Burris, an Indian orator, delivered the invocation in Chickasaw. The girls were educated as if they were white, but leaving there, most turned to the Indian world.

Living in rural poverty, without water, my grandmother was a quiet, tender woman. The double knot of America was tied about her and was inescapable. Like most of the Chickasaw women, she became an active churchgoer, practicing the outward shape of Christianity while retaining the depth of Indian traditional religion, a reverence for all life. She lived outside the confines of the white world within an older order, holding the fragments of an Indian way closed within her hands. She was the face of survival, the face of history and spirit in a place where even women were forced to take up arms to protect themselves. At death, she made a statement of resistance; her gravestone disavowed Oklahoma statehood. It reads: BORN AND DIED IN BERWYN INDIAN TERRITORY.

I remember her as the old woman of the turtles, who spoke to them and they listened, who cleaned fish, who cooked platters of eggs to feed her many grandchildren. She was the woman who never cut hair. She was the blue-eyed Indian who used lye and ash to turn corn into white, tender hominy, cooking in a black kettle. There is even a recipe for "Lucy's Lye soap." She was the woman, forced into English, who used snuff and healed her children with herbs, home remedies, and the occasional

help of a black Chickasaw freedwoman named Aunt Rachel, a root worker. My grandmother was the beautiful lover of land, people, and quiet Oklahoma nights full not only of remembered fear, but fireflies, and the smell of pecan trees, the land with tarantulas and rattlesnakes, the numerous and silencing sounds of gunshots in the night.

Like the redwood forests, when a mother tree falls, a young one springs from its death. I am one of the trees grown out of my grandmother's falling at a time when Indian dances were still outlawed, gatherings suspect.

The line where my grandmother ends and I begin is no line at all. I am a child who once lived inside her, who was carried inside the builders of the mounds, the cells of mourners along the Trail of Tears. From them I still remember to honor life, mystery, and this incomparable ongoing creation.

And living at the secret heart of this creation, I am the grandmother now, traveling among those who cannot see or know me, learning the healing of plants, caring for children, struggling against the madness called progress, and believing the sun's old ways. I know this land is charged with life. I know what has happened to it and to us. And I know our survival.

◄ AND ► *PICKING BLACKBERRIES* BY NORMA HOWARD.

◄ CHICKASAW PRINCESS DRESS MADE BY PAULINE BROWN. *PHOTO BY MATT BRADBURY*

▼ TURTLE SHELLS AND HATBANDS. MALE SINGERS WORE HATBAND WITH FEATHERS. TURTLE SHELLS WERE WORN BY WOMEN FOR STOMP DANCING, COLLECTED EARLY TWENTIETH CENTURY. *COLLECTION OF THE SMITHSONIAN CULTURAL RESOURCE CENTER, WASHINGTON, D.C.*

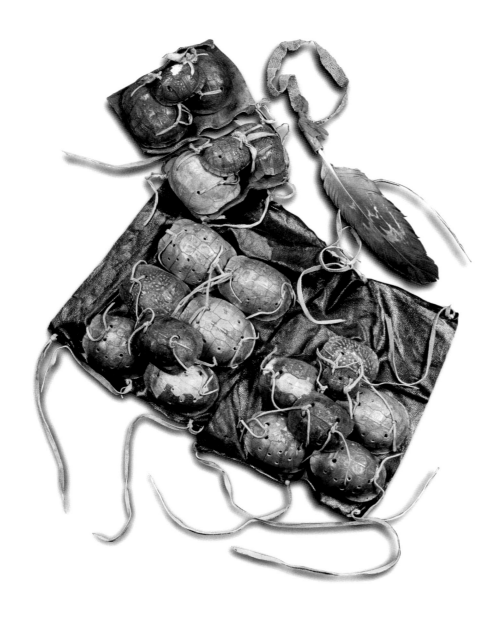

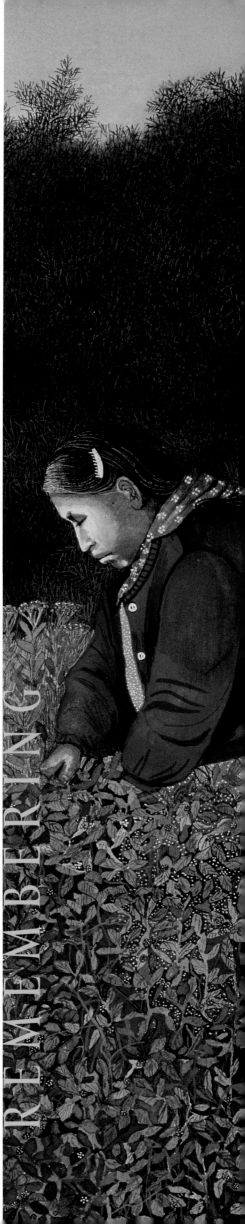

REMEMBERING

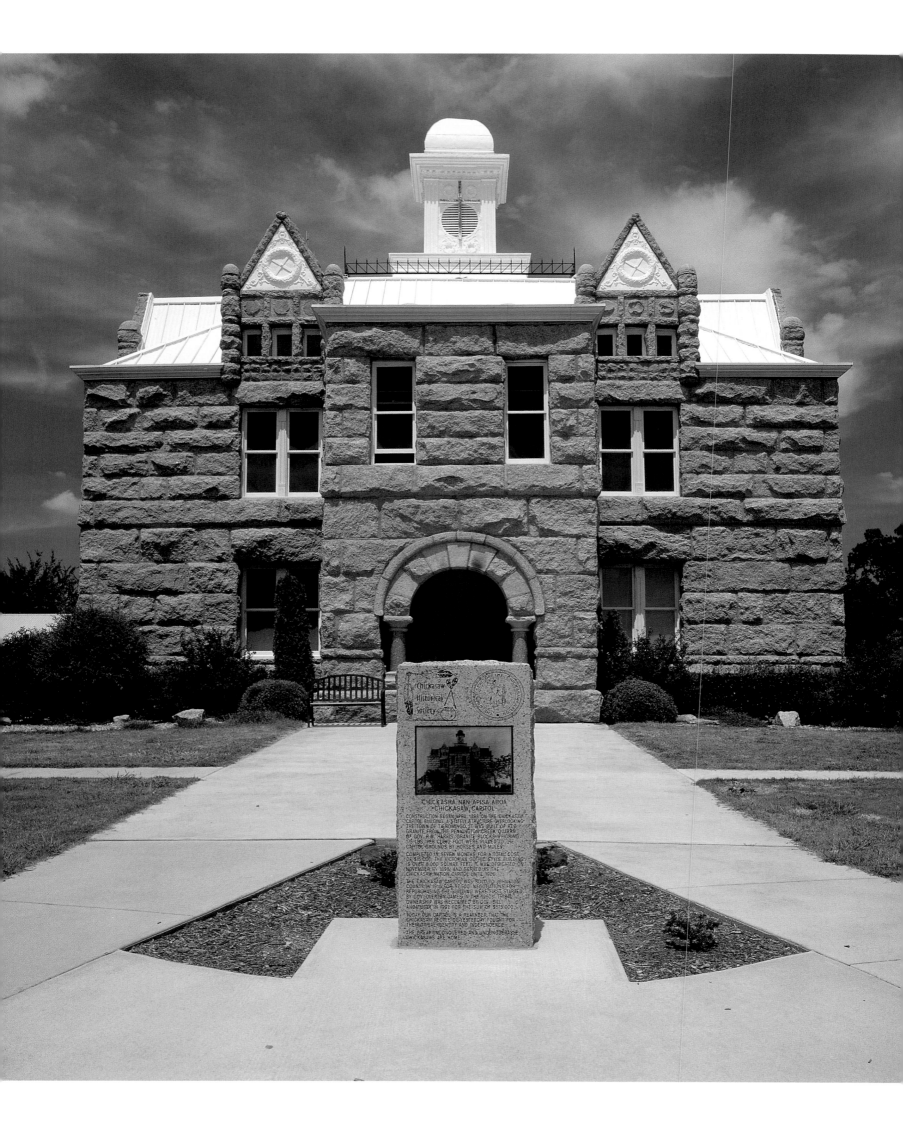

THE CHICKASAW NATION TODAY

by Jeannie Barbour

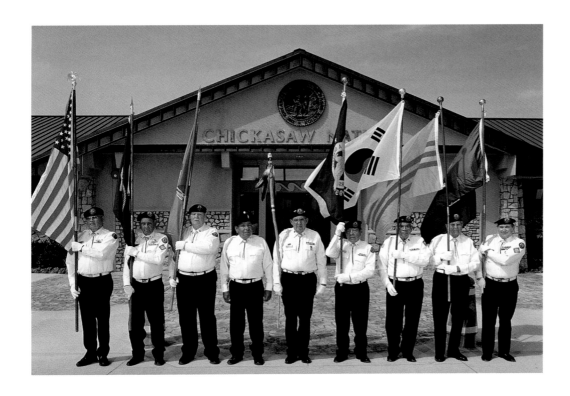

*The future of the Chickasaw Nation is based on
the preservation of its sovereign status as an independent government.
Tribal sovereignty is defined as the right of Indian tribes
to determine their own futures.*

The Chickasaw Nation today is economically strong, culturally vibrant, and possessed of energetic people still dedicated to the preservation of family, community, sovereignty, and heritage. Since the 1980s tribal government has focused most of its efforts on building an economically diverse base to generate funds that will supplement programs and services to Indian people. Businesses have flourished, programs and services have grown, and the quality of life for all Chickasaws has been greatly enhanced.

The future of the Chickasaw Nation is based on the preservation of its sovereign status as an independent government. Tribal sovereignty is defined as the right of Indian tribes to determine their own futures. Through their elected tribal governments, they operate as self-governing nations. As the United States government signed treaties with Indian nations down through history, they acknowledged the inherent sovereignty of tribes. Attributes of sovereignty include the power to determine a form

◀◀ NATIONAL CAPITOL BUILDING TODAY IN TISHOMINGO, OKLAHOMA.

▲ THE CHICKASAW NATION HONOR GUARD IN FRONT OF GOVERNMENT HEADQUARTERS IN ADA, OKLAHOMA. PICTURED FROM LEFT TO RIGHT ARE BERNIE SEELEY, JIM PERRY, WILL JOHNSON, BILL FRAZIER, BOB ROSS, WARREN REED, SIM GREENWOOD, BILL QUINCY, AND SOLOMON GANTT.

▼ CHICKASAW BOOK OF LAWS CONTAINS THE
CONSTITUTION WRITTEN IN THE CHICKASAW
LANGUAGE.

▲ GOOD SPRING, SITE OF 1856 CONSTITUTIONAL
CONVENTION IN TISHOMINGO, OKLAHOMA.

of government, to define conditions for citizenship, to administer justice and law, to tax, to adjust domestic relations of its members, and to regulate property tax.

The right to maintain its own government has been upheld for the Chickasaw Nation since the 1830s. At that time, federal courts affirmed a trust responsibility toward the tribe. This trust includes the protection of tribal interests and rights, especially with regard to tribal lands and resources. It is important to understand that although Congress exercises plenary power over Indian affairs, all sovereign powers are held by Indian nations, not the U.S. government. The only power the United States has over tribes in America is the power that tribes allowed them to have. This power was given in treaties, agreements, or the occasional act of Congress.

Throughout history, attempts have been made to wear away tribal sovereignty. Trade and allotment acts constructed by the federal government were successful in gaining Indian lands for the national purpose. Assimilation policies were designed to destroy tribal cultures and incorporate Indian people into mainstream society. All had detrimental effects on the Chickasaw people, but the Chickasaws persevered. At every step in Chickasaw history, tribal leaders have wisely negotiated for the protection of sovereignty.

The Chickasaw Nation's current three-branch system of government was established with the ratification of the 1983 Chickasaw Nation Constitution. All of the elected officials provided for in the Constitution share in a commitment that

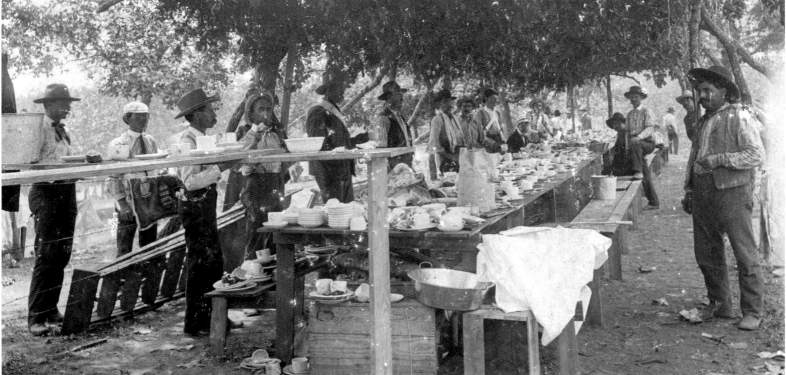

government policy serves the common good of all Chickasaw citizens. This common good extends to future generations as well as to today's citizens. Chickasaw Nation government seeks to protect individuals as well as provide a platform for a smooth-running administrative structure.

More and more Chickasaws are taking the opportunity to participate in tribal government, service to their community, and the electoral process. They know the values and policies they support and they are in constant contact with their legislative, judicial, and executive representatives. Those who choose to serve Chickasaws as elected officials are most successful when they demonstrate political savvy, openness to different political perspectives, and an advanced level of spiritual maturity.

▲▲ JOHN HERRINGTON, FIRST NATIVE AMERICAN ASTRONAUT TO FLY IN SPACE, AND PEARL CARTER SCOTT, TAUGHT TO FLY BY WILEY POST AND MEMBER OF AVIATION HALL OF FAME.

▲ CHICKASAW TRIBAL DAY FEAST UNDER ARBOR, CA. NINETEENTH CENTURY. *COURTESY OF THE CHICKASAW COUNCIL HOUSE MUSEUM, TISHOMINGO, OKLAHOMA.*

The structure of our current government encourages and supports infrastructure for strong business ventures and an advanced tribal economy. The use of new technologies and dynamic business strategies in a global market are encouraged. As in times past, the Chickasaw work ethic is very much a part of everyday life today. Monies generated in business are divided between investments for further diversification of enterprises and supporting tribal government operations, programs, and services for Indian people. This unique system is key to the nation's efforts to pursue self-sufficiency and self-determination.

In the Book of Matthew we are reminded that "the nations" will be judged by how they treat "the least among us." There is a similar belief in Chickasaw tradition, which insists that every member of the tribal community provide for every other member. In times past, without question, all shared resources. Today's answer, in support of community, is through jobs, health care, education, social programs, and housing.

Preservation of community starts at home. As Chickasaw families struggle to make ends meet, they are faced with cuts in federal programs offering opportunities to many

▼ TAKING CARE OF OUR CITIZENS— (LEFT TO RIGHT) PHILLIP WOOD, CHICKASAW LIGHTHORSE POLICE; TOMMY SCHULTZ (KNEELING) BIA FIREFIGHTER; RON BROWN, EMS; DEREKAH KILCREASE AND ROMAN KILCREASE, SEARCH AND RESCUE.

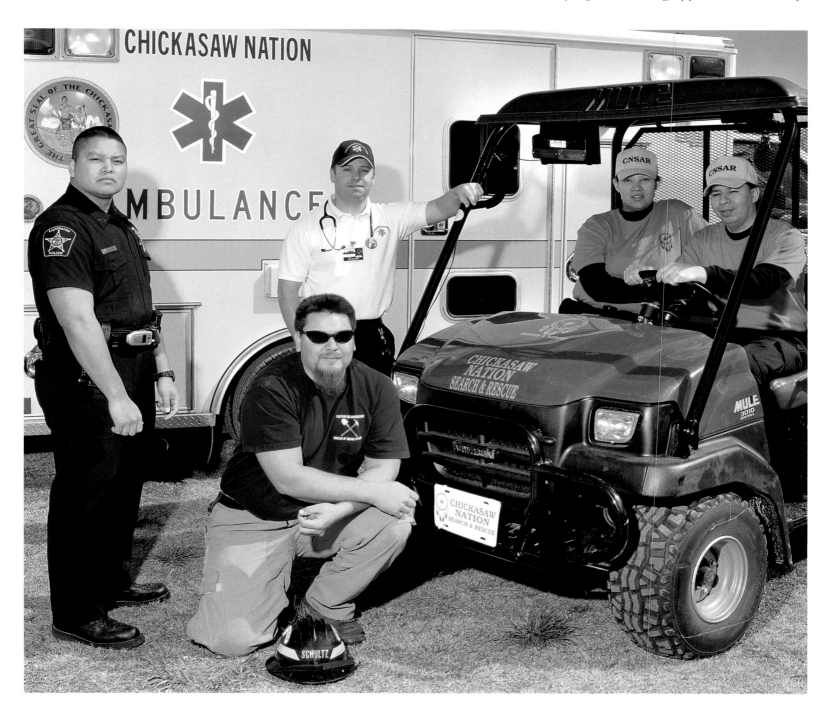

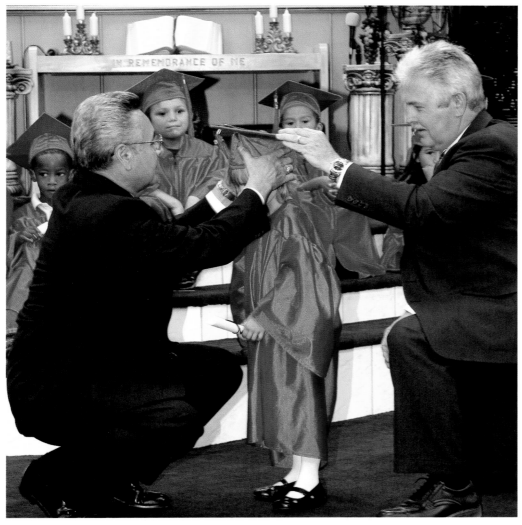

◀ CHICKASAW HEAD START GRADUATE
CASSIDY MOTT RECEIVES A HELPING HAND
FROM LIEUTENANT GOVERNOR JEFFERSON
KEEL (LEFT) AND EARLY CHILDHOOD
DIRECTOR DANNY WELLS (RIGHT) ON
GRADUATION DAY IN DUNCAN, OKLAHOMA.
OTHER GRADUATES PICTURED FROM LEFT ARE
DAZAMIAN PRINCE, ANTHONY CONN, MARIO
HERNANDEZ, AND CAITLYNN SULLIVAN.
PHOTO BY MIKE MCKEE

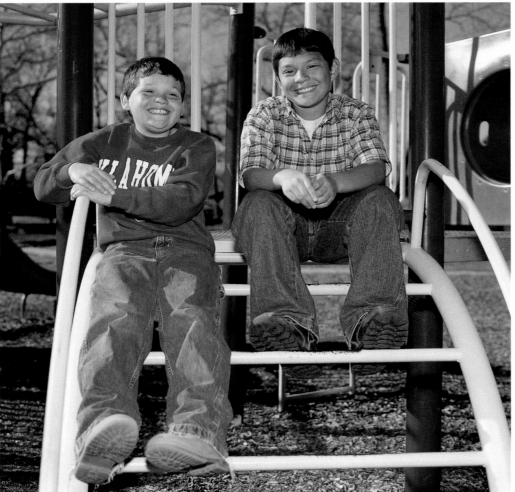

◀ CHICKASAW YOUTH QUANNAH AND
SEQUOYAH LINDSAY.

▲ INDIAN FAST PITCH SOFTBALL IS ENJOYED BY
MANY, INCLUDING RICK AND SHERRI MILLER,
DAUGHTERS CYDNEE AND MAKYNLEE WITH
ROBERT HAMILTON AND GEARY BLEVINS AT
MILL CREEK, OKLAHOMA, WHERE FAMILY
TOURNAMENTS ARE OFTEN PLAYED.

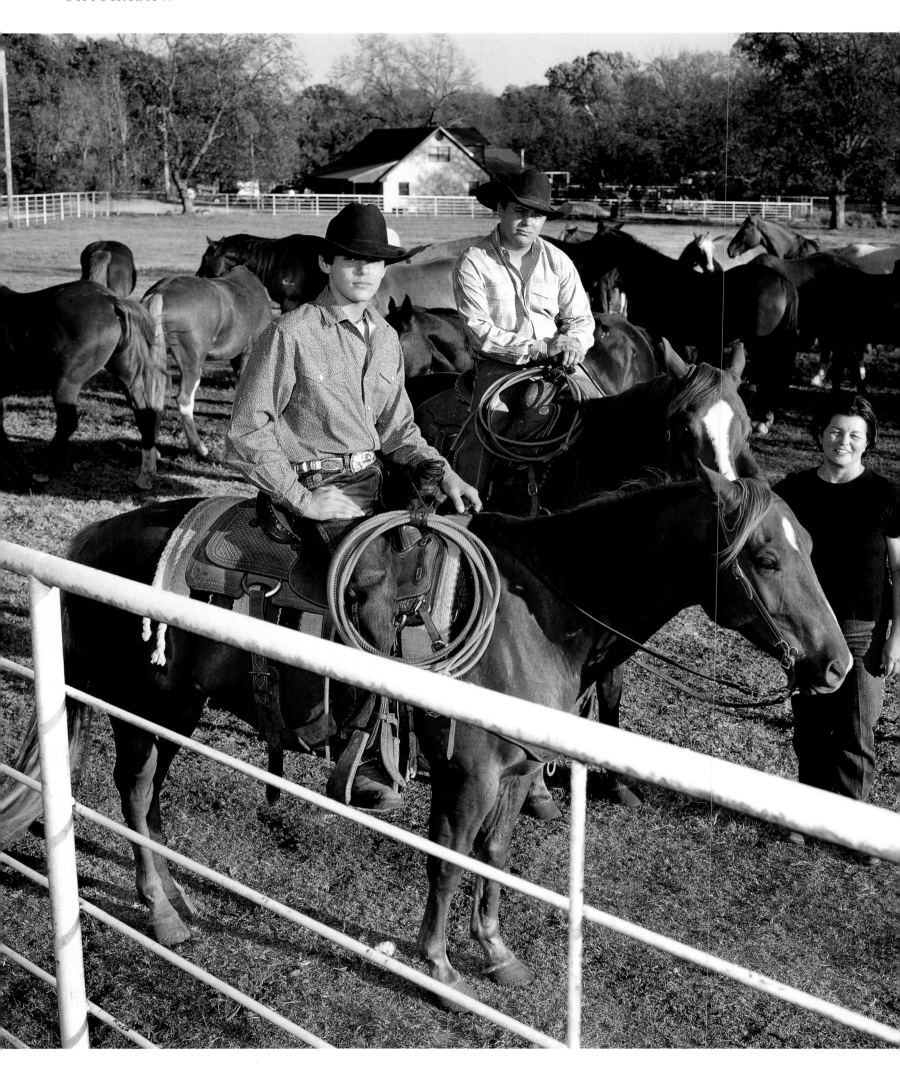

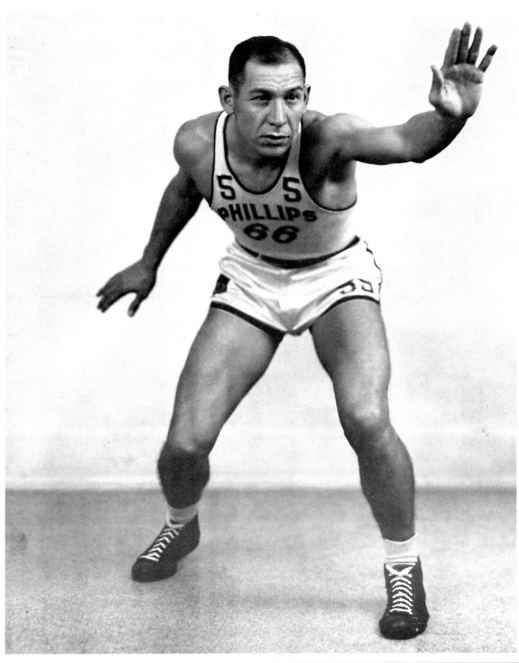

◄◄ KAREN COOK WITH SONS TODD AND CASEY AT THEIR HORSE RANCH IN MADILL, OKLAHOMA.

◄ CAB RENICK, FIRST NATIVE AMERICAN ON AN OLYMPIC BASKETBALL TEAM, WINNING THE GOLD MEDAL FOR BASKETBALL IN 1948 IN LONDON, ENGLAND. *COURTESY OF THE CHICKASAW COUNCIL HOUSE MUSEUM, TISHOMINGO, OKLAHOMA.*

▼▼ CHICKASAW STICKBALL TEAM IN ACTION DURING THE CHI KA SHA REUNION AT KULLIHOMA, OKLAHOMA.

▼ CRAVATT FAMILY ENJOYS A GAME OF BASKETBALL AS A FAVORITE PASTIME SPORT.

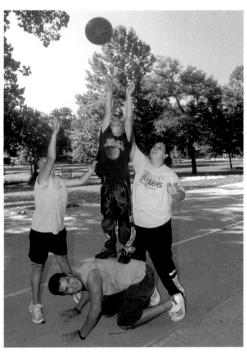

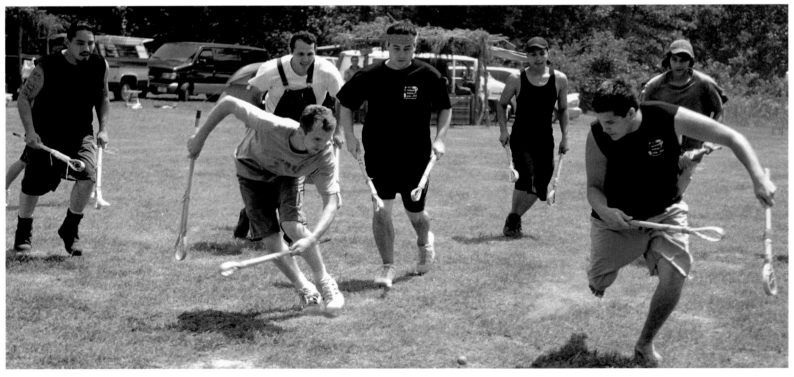

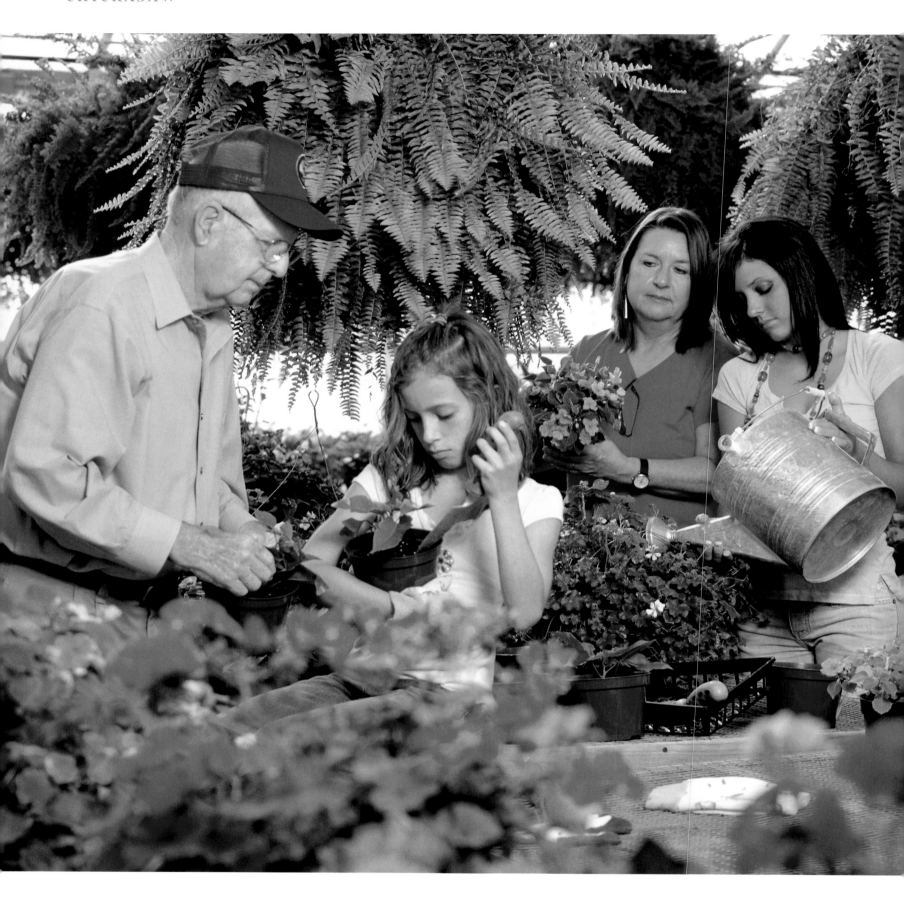

▲ Joe Kent Abbott, Sydney Abbott, Thalia Abbott Miller, and Colbi Howard carry on a 100-year business.

► "From pashofa to chocolate." Micah Hart at the Chickasaw Bedre' chocolate factory, in Pauls Valley, Oklahoma.

who are at the bottom of the economic ladder. Programs for public education, college loans, medical care, housing, and nutrition are in danger of being eliminated altogether. Once again, Chickasaw traditional belief in the support of all its citizens demands action. Elders are cared for through senior citizen sites. Children are offered a wide variety of educational opportunities for every age group, no matter the economic standing of their families. Parents are given the needed support required in maintaining healthy lifestyles in a modern age. Where a need is determined,

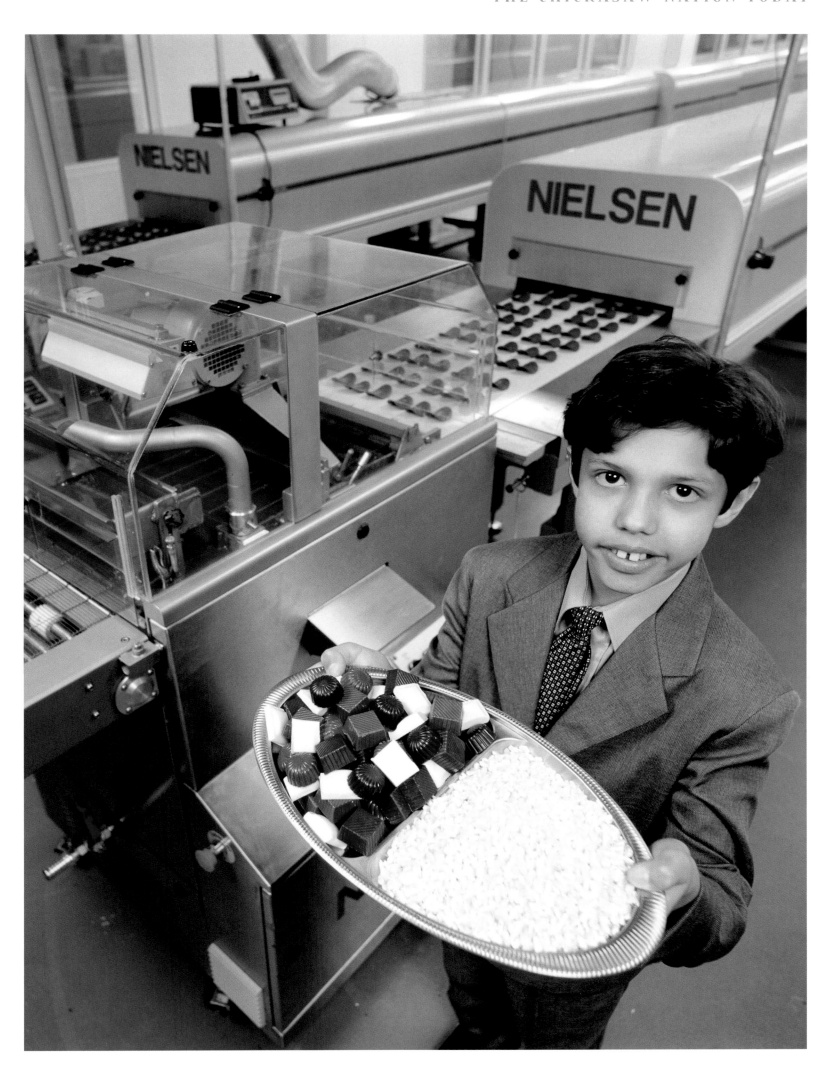

CHICKASAW PRINCESSES, AMBASSADORS FOR
THE NATION, 1971 TO 2005.

LEFT SIDE:
LEFT TO RIGHT BEGINNING WITH THE
FRONT ROW: MONICA SEAWRIGHT, CLARICE
MONETATHCHI SHIRLEY; **MIDDLE ROW:**
CHERI BELLEFEUILLE-ELDRED, ERIN BROWN;
BACK ROW: SAMANTHA WISDOM GROSS,
FRANCINE ALLEN PARCHCORN, BARBARA
BOSTON UNDERWOOD, CRYSTAL
UNDERWOOD, DEBBIE SEELEY JACKSON,
RACHEL STICK WEDLOW, MELODY COOPER,
CANDICE WISDOM, GAYLE SHIELDS CLARK.

RIGHT SIDE:
SEATED: JOHNNA WALKER;
BACK ROW STANDING: DEBORAH ALEXANDER
WALKER, LISA NAIL IMPSON.

CHICKASAW PORTRAITS

Etna Cooke, **Lillie Ward**, and **Irene Digby** are tribal elders from Davis and Sulphur, Oklahoma, who enjoy speaking and singing in the Chickasaw language.

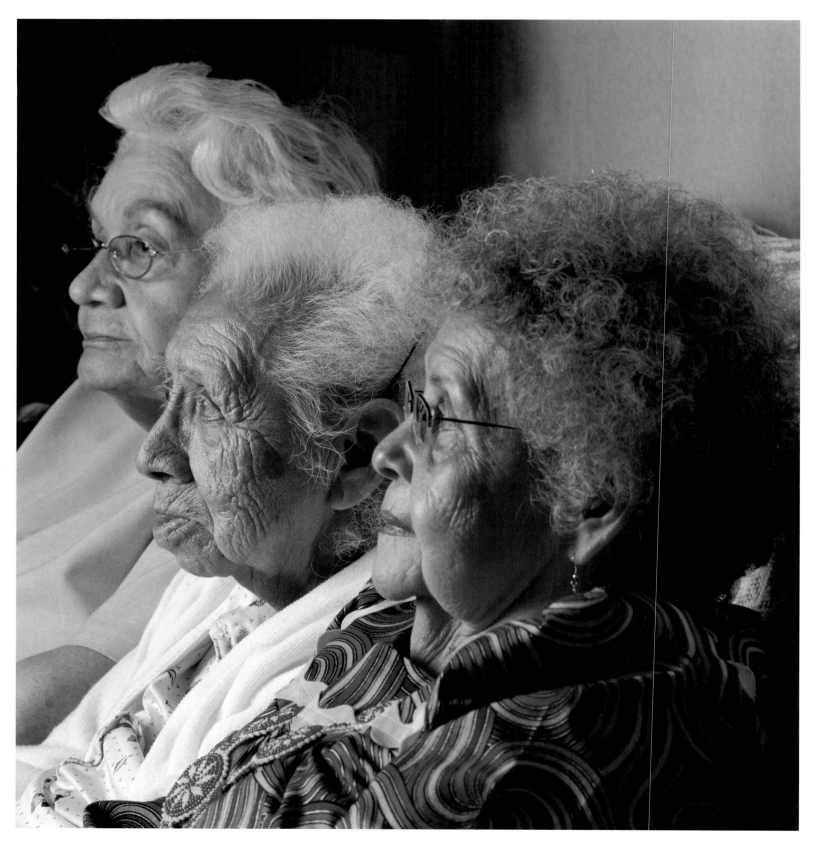

Hattie Harjo is a loving mother and grandmother who still lives on her original allotted land in Stonewall, Oklahoma.

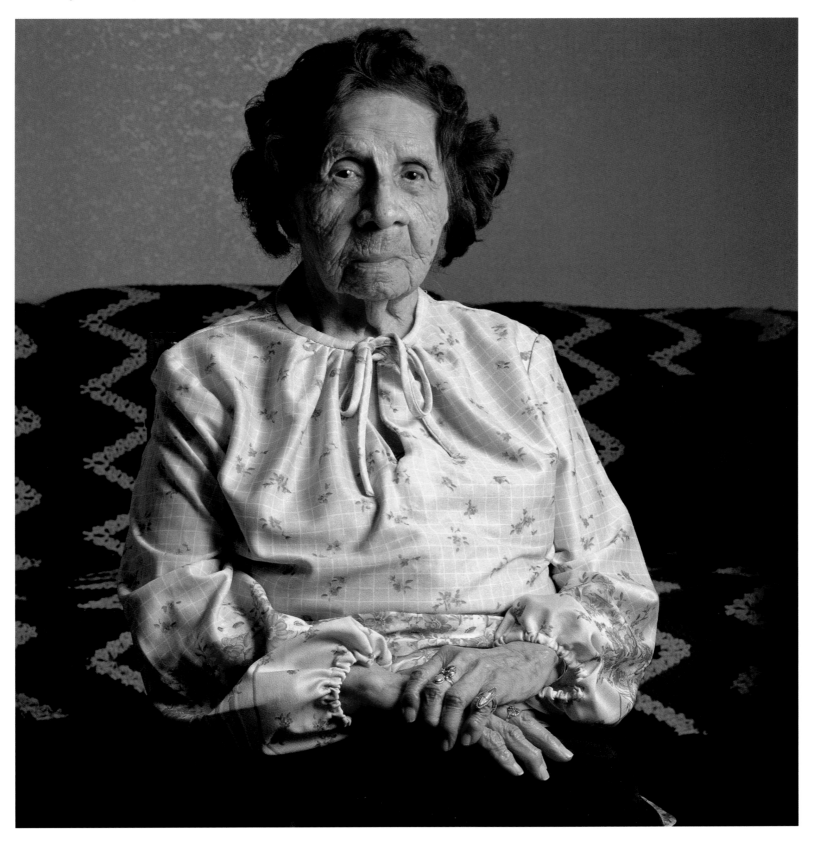

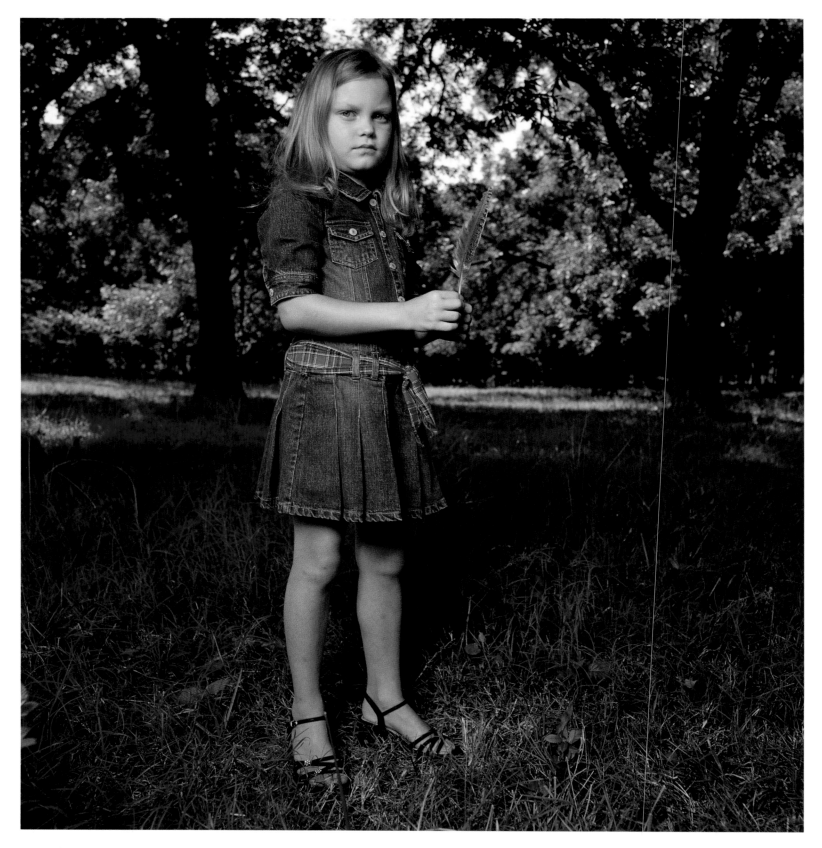

Samantha is the daughter of Jason and Hillery Perry. She is a direct descendant of Chickasaw governor Cyrus Harris, and the family is related to Edmund Pickens, William Guy, and Robert Maxwell Harris.

Flora Perry, tribal elder and fluent speaker, is a distant relative of Chickasaw leader Ayakatubby. She shares traditional and cultural values, such as the pashofa ceremony and making home remedies from sassafras and broomweed tea—with the younger ones who want to learn.

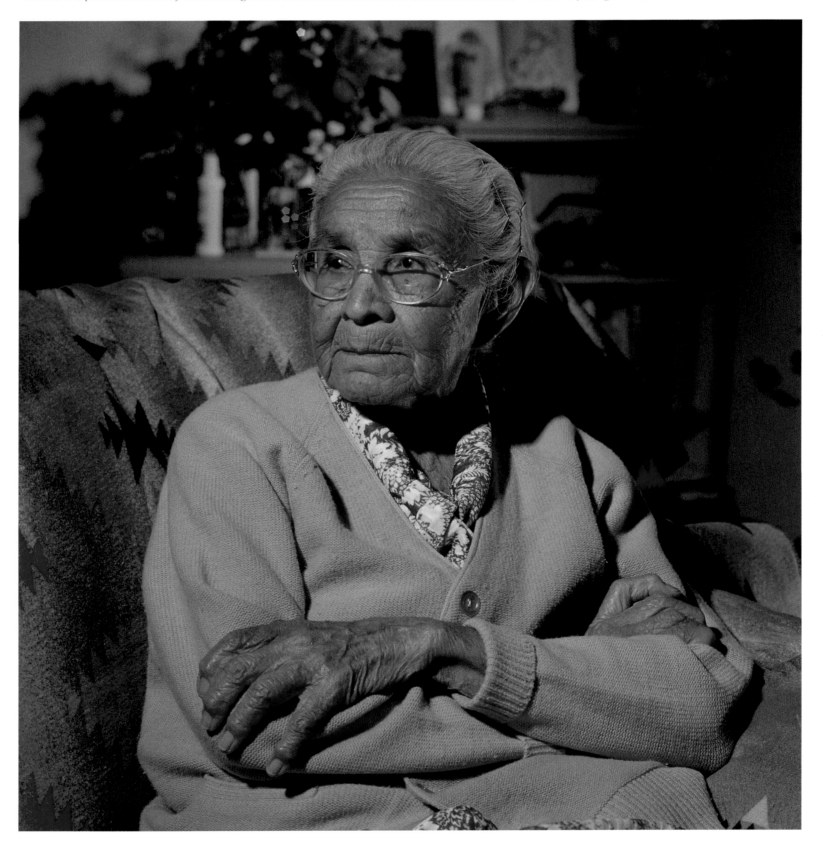

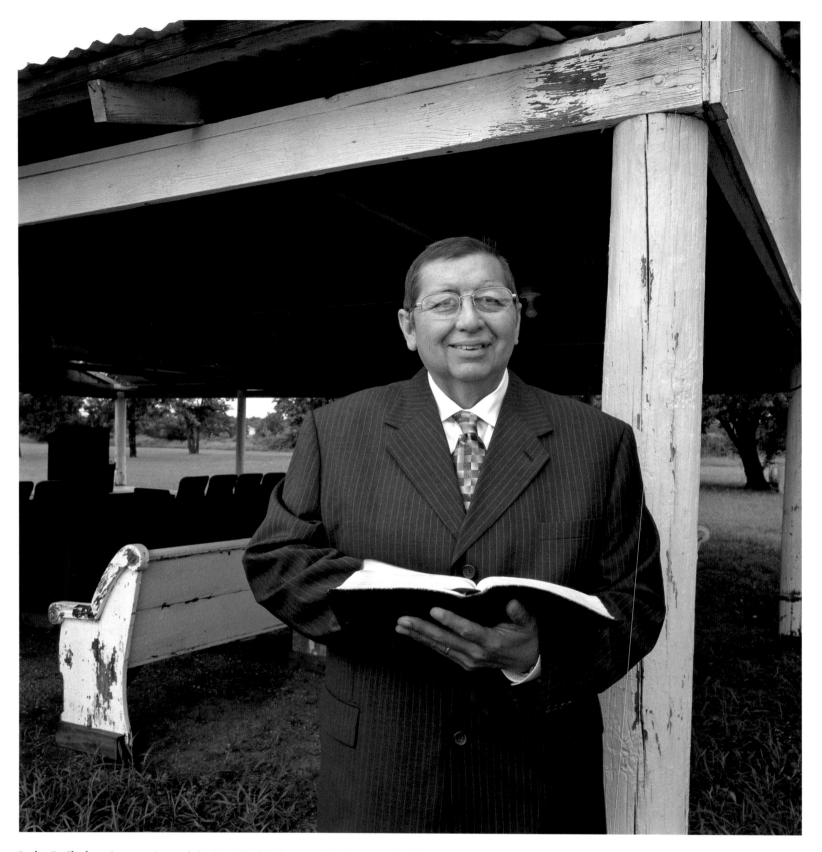

Leslie D. Clark is the grandson of the late Abel B. Brown who also preached for many years among the Chickasaws and the great-grandson of Cyrus Harris, the first territorial governor of the Chickasaw Nation. Leslie pastors Centerpoint Baptist Church in Ardmore, Oklahoma.

Larry and JoAnn Hawkins minister through sermon and gospel singing at Blue, or Okchamali, Baptist Church in Connerville, Oklahoma. Larry has been the pastor for twelve years and JoAnn, the pianist. He is the grandson of Charles Fulsom, and JoAnn's grandmother was Mary Collins-Cravatt.

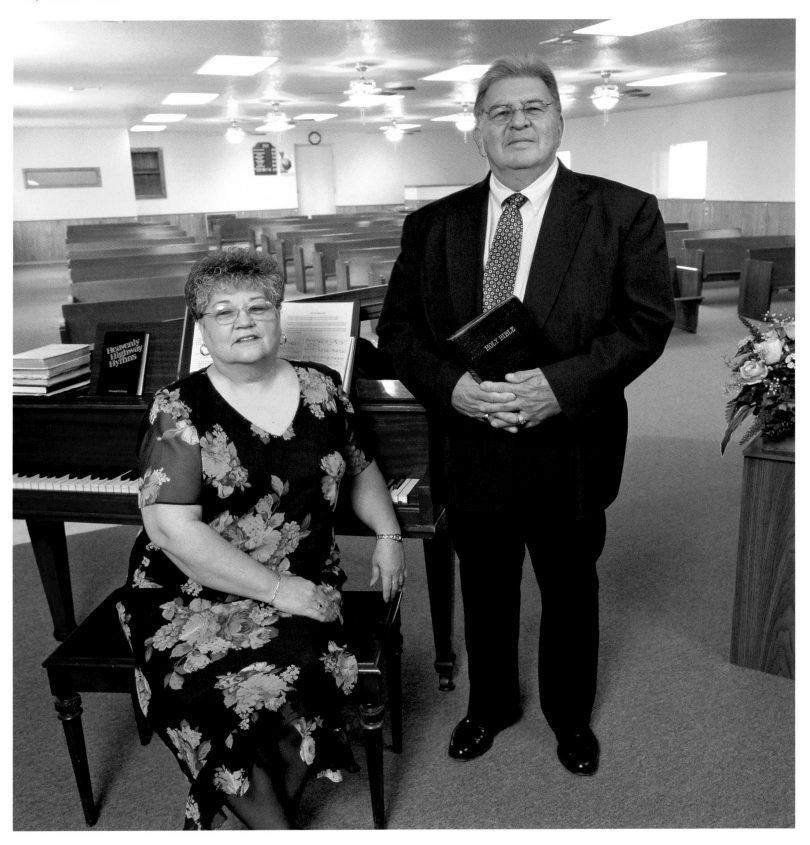

Overton "Buck" Cheadle is a graduate of Chilocco Indian School, a former Chickasaw legislator, educator, and award-winning coach. He was inducted into the Chickasaw Hall of Fame in 1994 and is still active in tribal affairs.

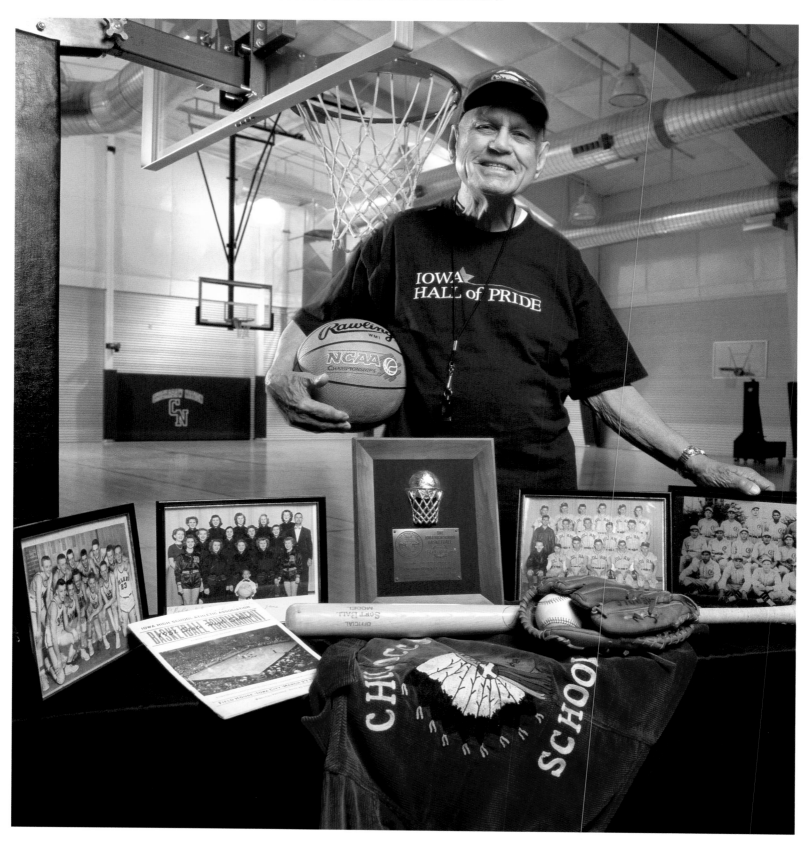

Charlie Carter (right) is a traditional bow maker who learned his craft at the age of eight. He also enjoys sharing his faith and has been preaching for over twenty years. **Wayne Walker** (left) learned about bow making from his father and grandfather, and he also tans hides, beads, and makes stickball sticks. Charlie and Wayne both enjoy preserving traditions by teaching others.

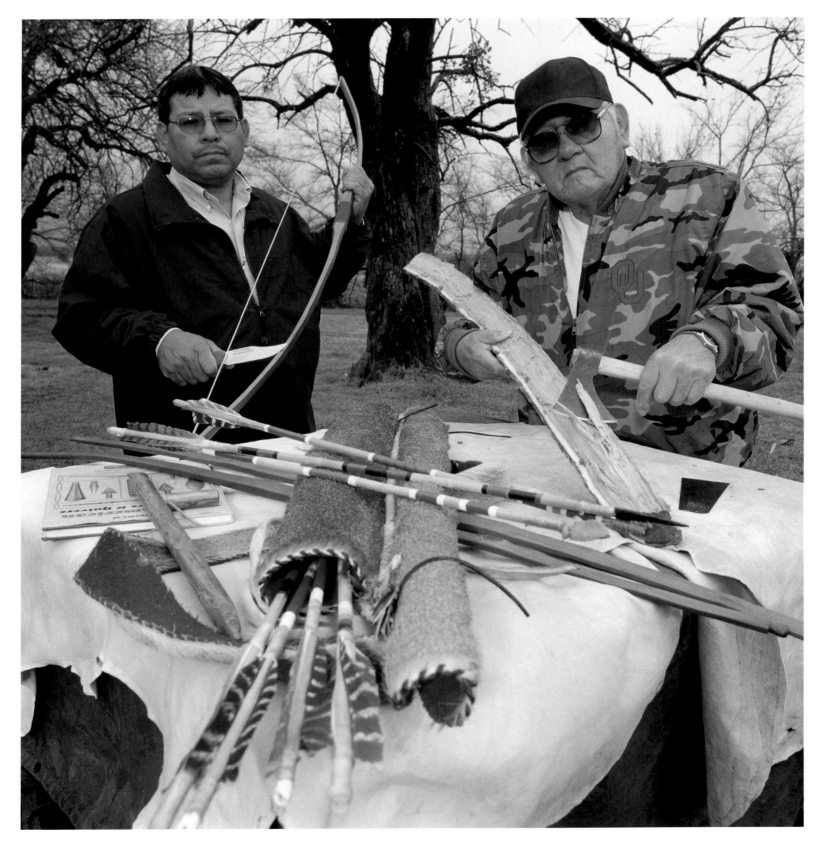

Both traditional language speakers and cultural preservationists, **Emily Dickerson** and her son **Carlin Thompson** are revered for their cultural knowledge of Chickasaw traditions, values, foods, and medicines.

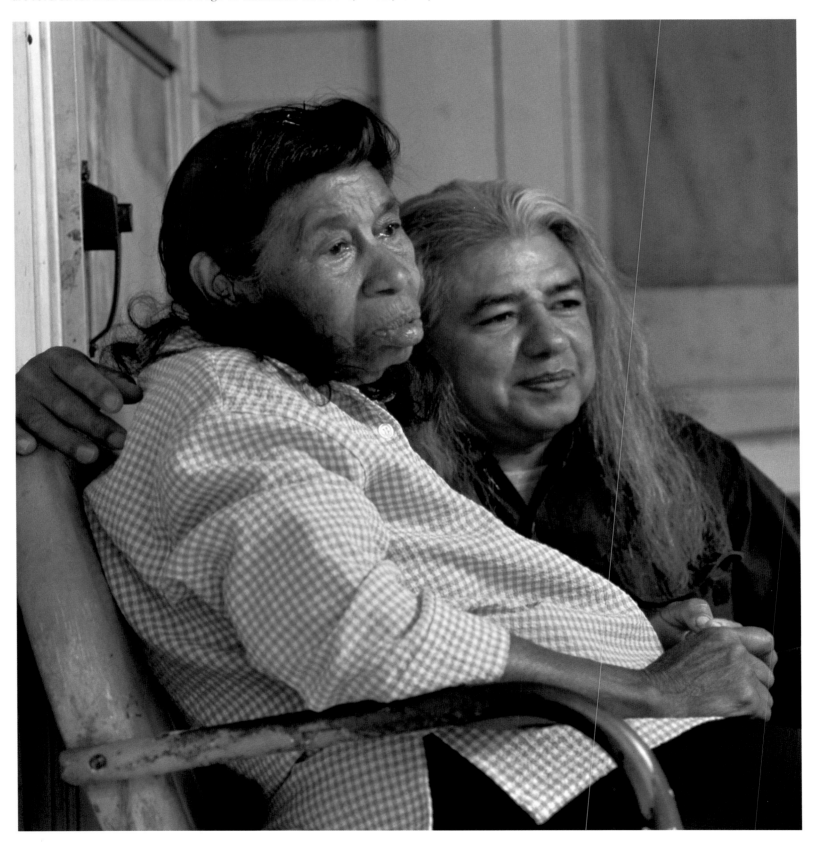

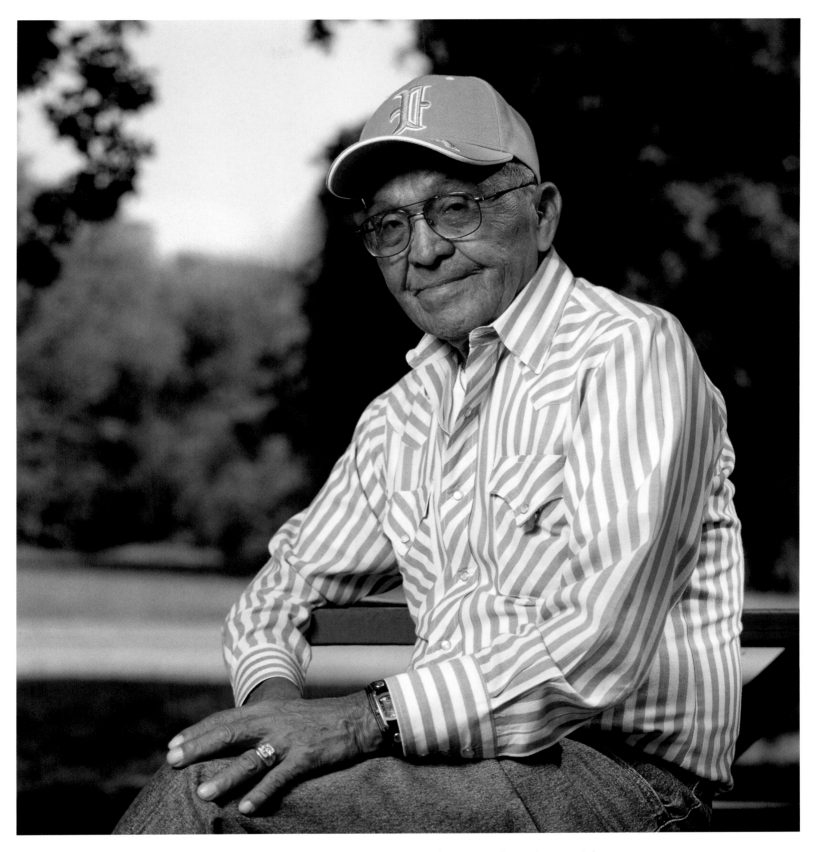

Decorated war veteran **John Puller** served six years during WWII under General Patton in the 2nd armored division.
He served the next three years in the navy and later three years in the air force.

Gene, Ted, and **Chet Underwood**, pictured at Pennington Creek, are the sons of Joe and Mary Underwood. These Chickasaw brothers enjoy the outdoors, hunting, camping, and spending time with family.

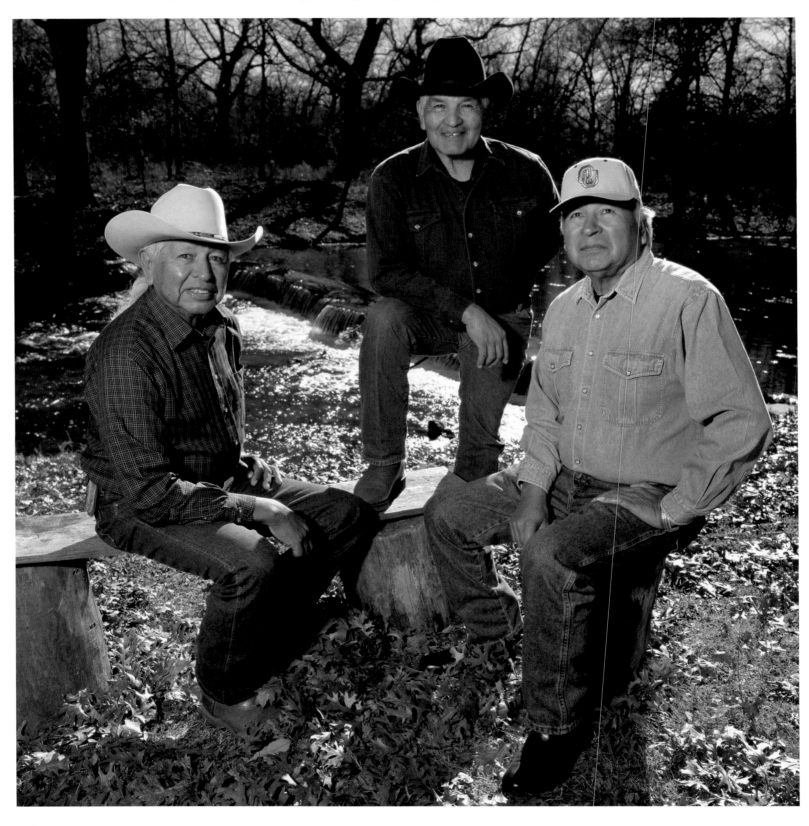

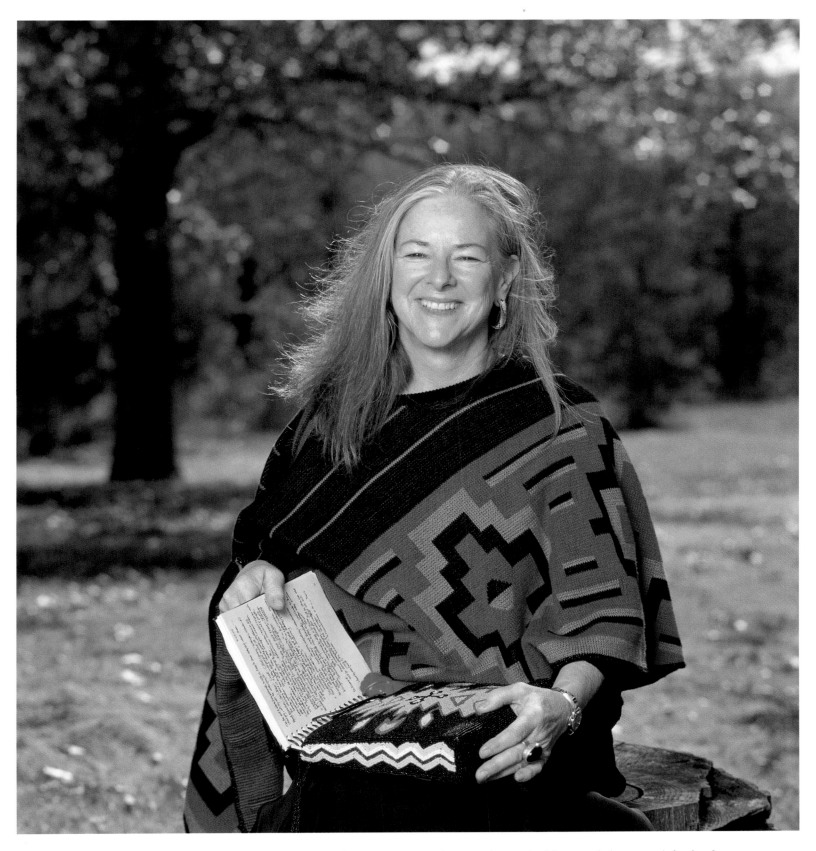

Linda Hogan, poet, novelist, playwright, and activist, is one of Native American literature's most highly regarded writers. A finalist for a Pulitzer Prize, Linda has earned many awards and fellowships for her works.

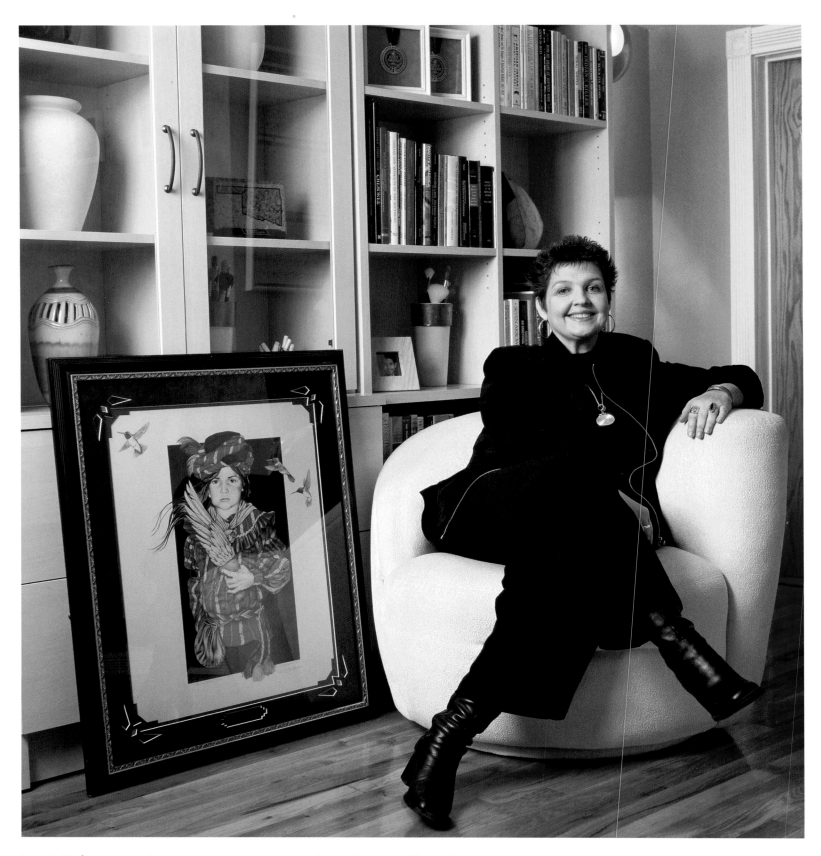

Jeannie Barbour is a mother, acclaimed artist, writer, and tribal historian. She is often engaged in lectures, workshops, and commissioned art projects. Active in marketing and promotion, she is also the niece of sculptor Clayburn Straughn, who was inducted into the Chickasaw Hall of Fame and named as Master Artist by the Five Civilized Tribes Museum.

An artist for more than forty years, **Mike Larsen** captures history through his paintings and sculpture. He was named Master Artist by the Five Civilized Tribes Museum and inducted into the Chickasaw Hall of Fame in 2000. Mike was commissioned to paint a series of portraits, Living Elders of the Chickasaw Nation, which he says has become a "labor of love."

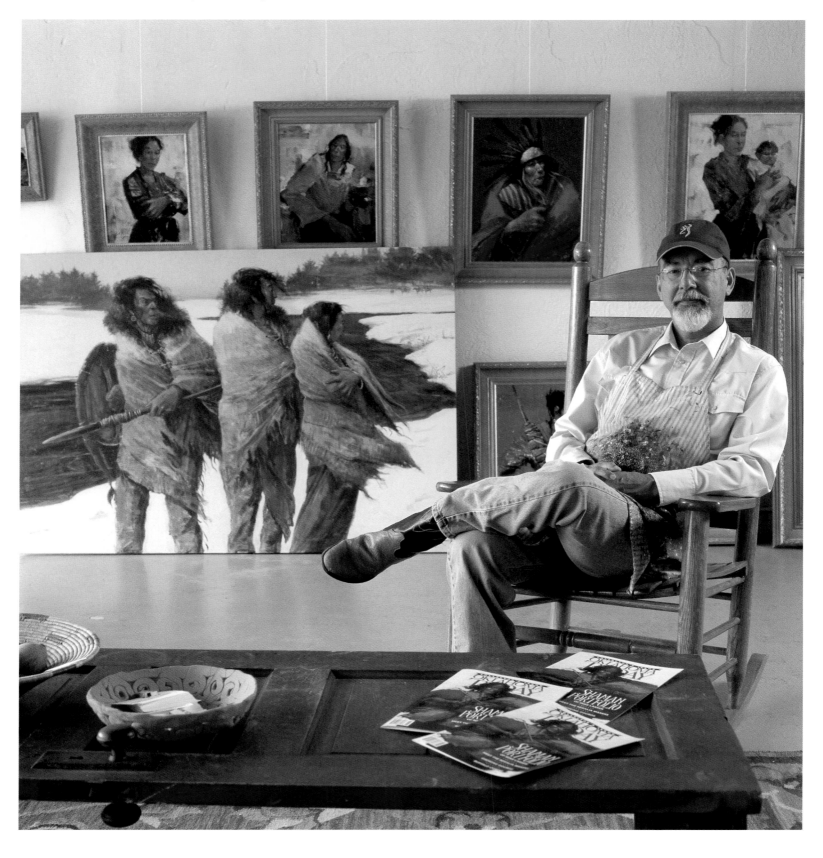

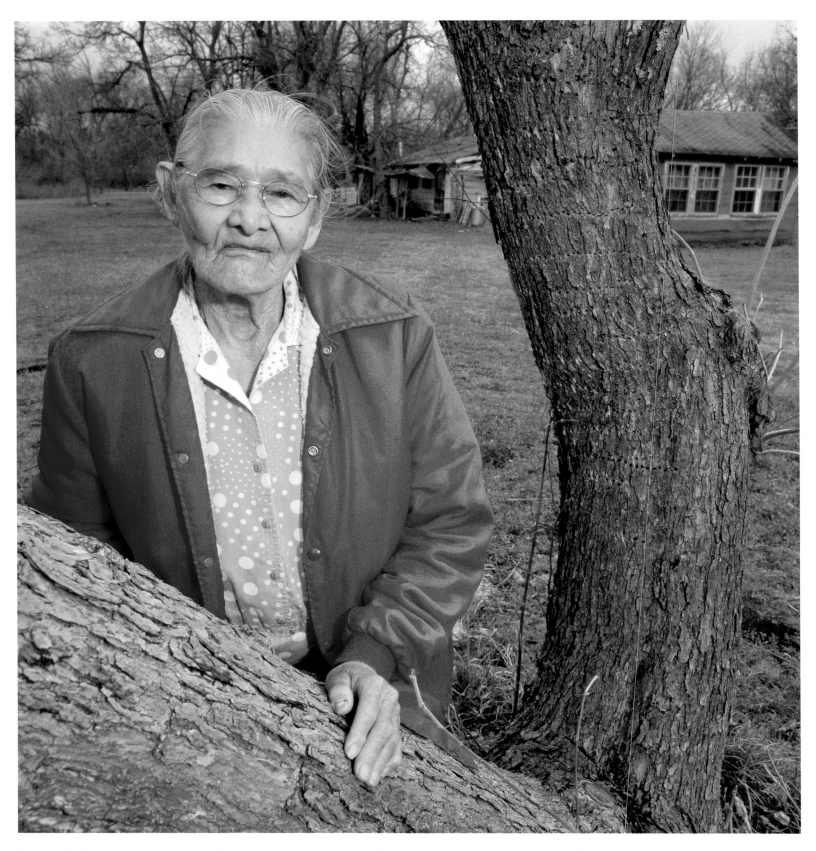

Pauline Walker is a traditionalist and Chickasaw language speaker. She is shown at her original homestead near the community of Kullihoma, Oklahoma.

Posing in front of Johnson Chapel on his father's original allotment, **Sam Johnson** is pictured with his relatives **Anderson "Cubby" Shield** and **Lee Fannie Roberts**— all descendants of Puknatubby—who grew up near the community of Kullihoma, Oklahoma. They can trace their ancestry to the Raccoon Clan.

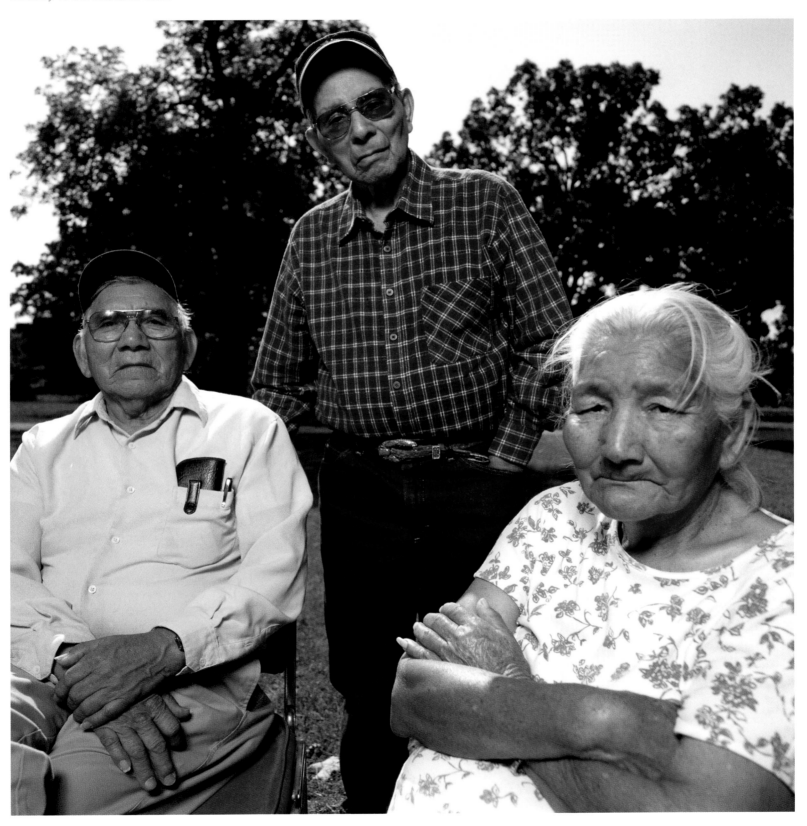

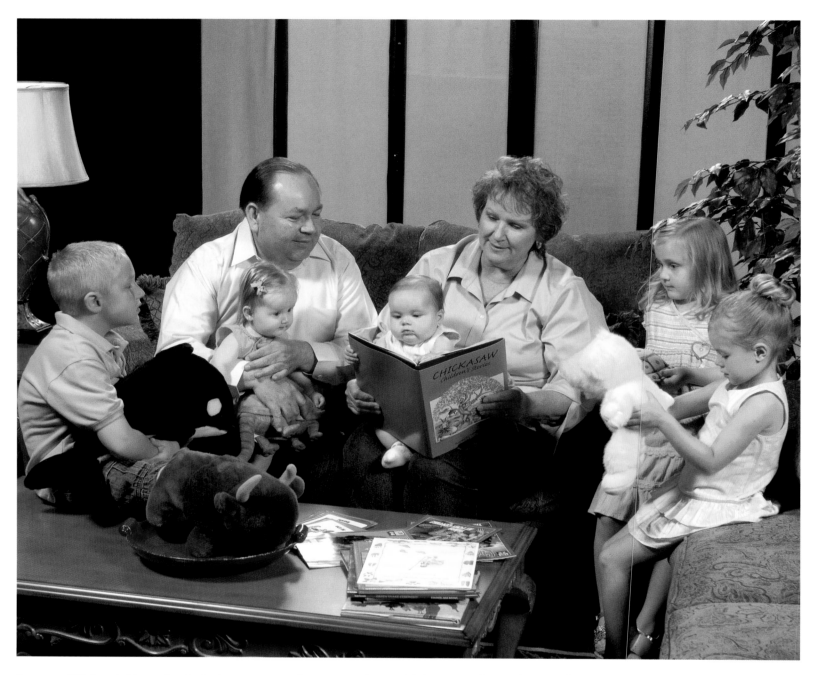

Governor **Bill Anoatubby** and wife, **Janice**, enjoy spending time with grandchildren **Brendan**, **Sydney**, **Preslea**, **Eryn**, and **Chloe**.

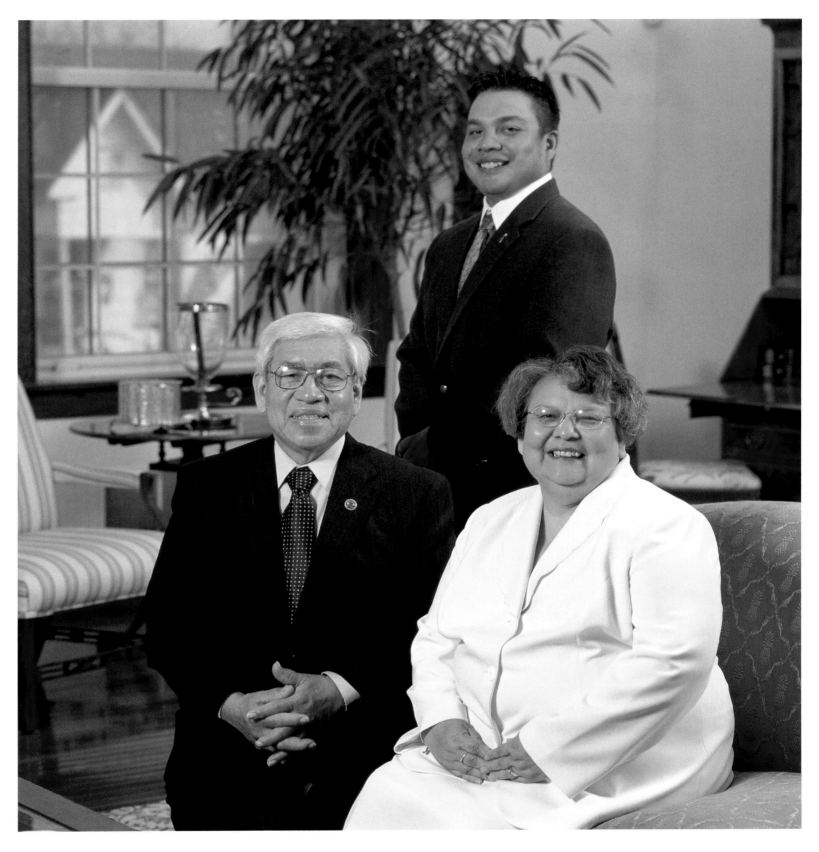

Kennedy Brown, wife **Richenda**, and son **Kelly**, a prominent family who continue to provide leadership in culture, heritage, and language preservation.

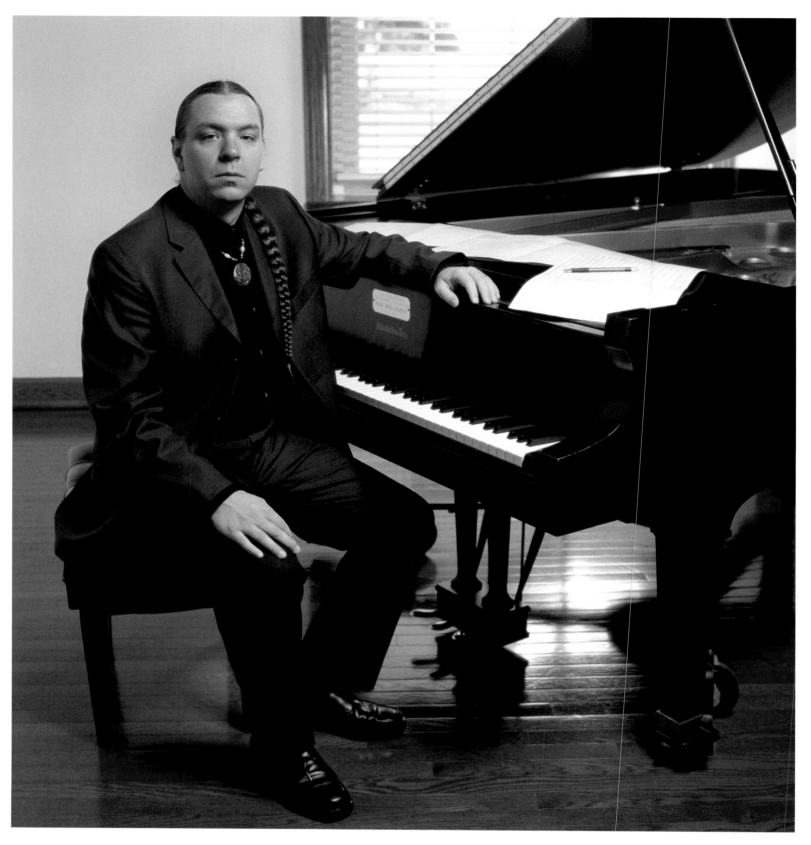

Jerod Impichchaachaaha' Tate is a musician and composer who credits his mother for launching his career by commissioning his first piece. Jerod feels her spirit lives on as he teaches other American Indians to find their voice in classical composition.

Deanna Hartley-Kelso serves as the Chickasaw Nation attorney general and administrator for the Justice Division. Besides serving on numerous boards and committees, she also represents the Chickasaw Nation at the United Nations Working Group on the Draft Declaration of the Rights of Indigenous Peoples, in Geneva, Switzerland.

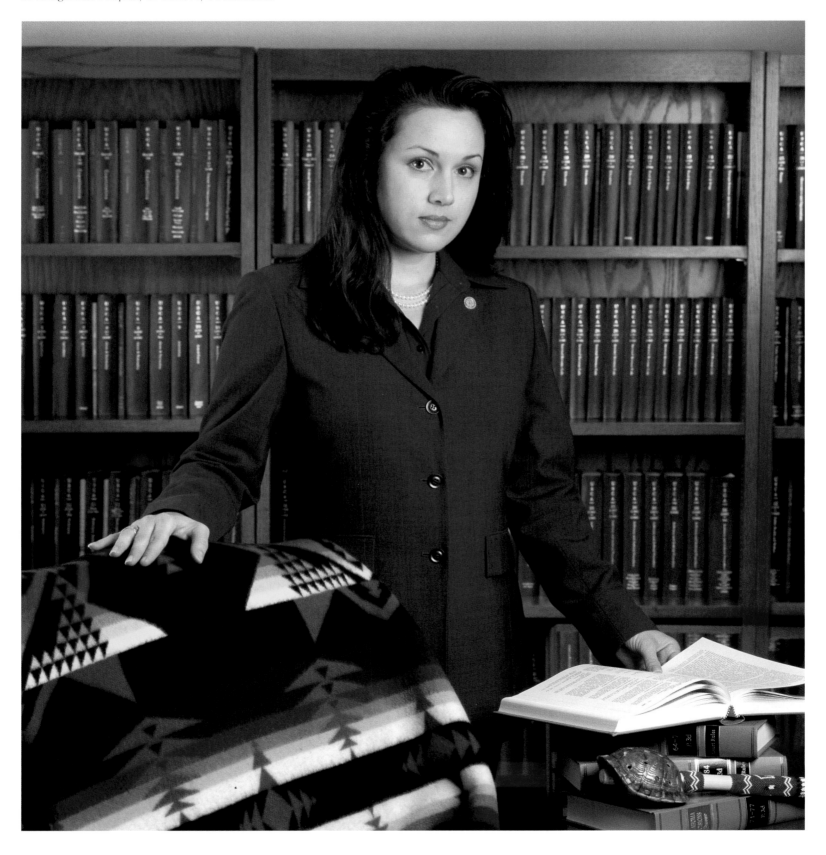

Charles D. Blackwell, Chickasaw ambassador to the United States of America, at his home in Washington, D.C.

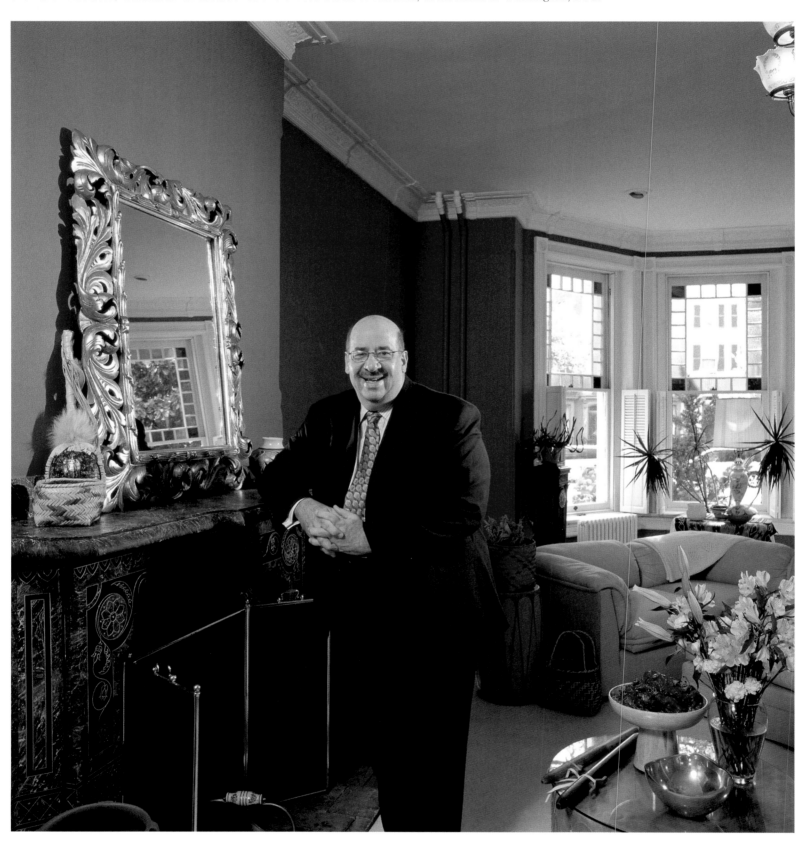

Oklahoma Hall of Fame inductee **William Paul** was formerly a managing partner of Oklahoma's oldest and largest law firm and past president of the American Bar Association. The son of a former Oklahoma senate president and great-grandson of a senator of the Chickasaw Nation in the 1800s, William's ancestors founded Pauls Valley, Oklahoma.

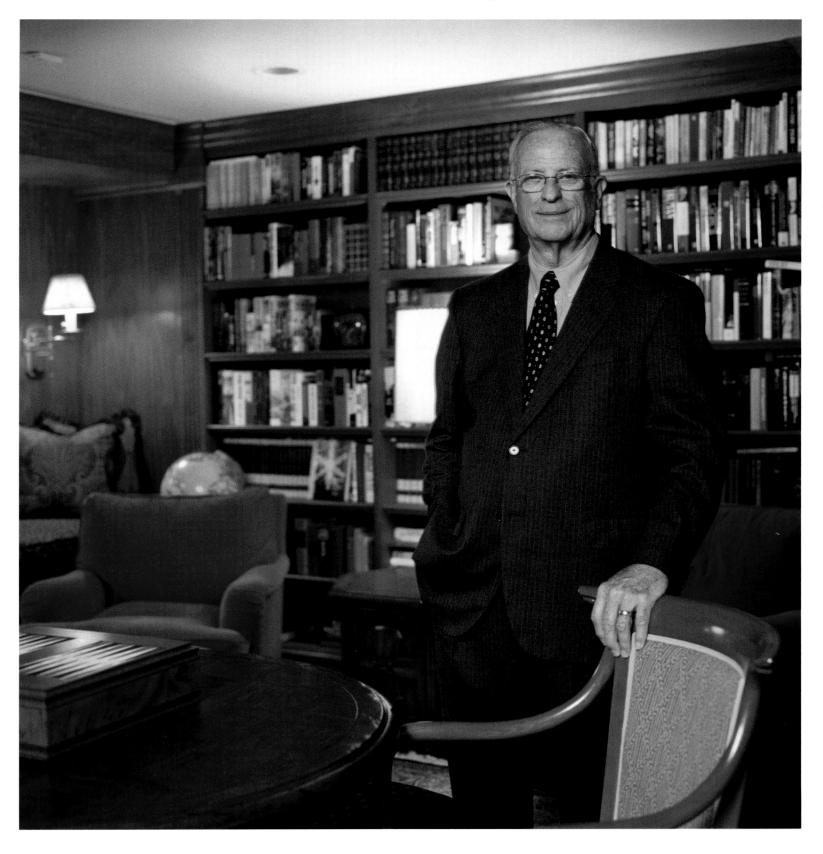

Retired U.S. Navy Commander **John B. Herrington** became the first Native American astronaut to fly in space in November 2002 when he traveled to the International Space Station (ISS) aboard the Space Shuttle *Endeavour*. Upon reaching ISS, Herrington was involved in helping to build the Station, performing three space walks to install the P1 Truss. Herrington enjoys talking to groups of children and others about his experiences.

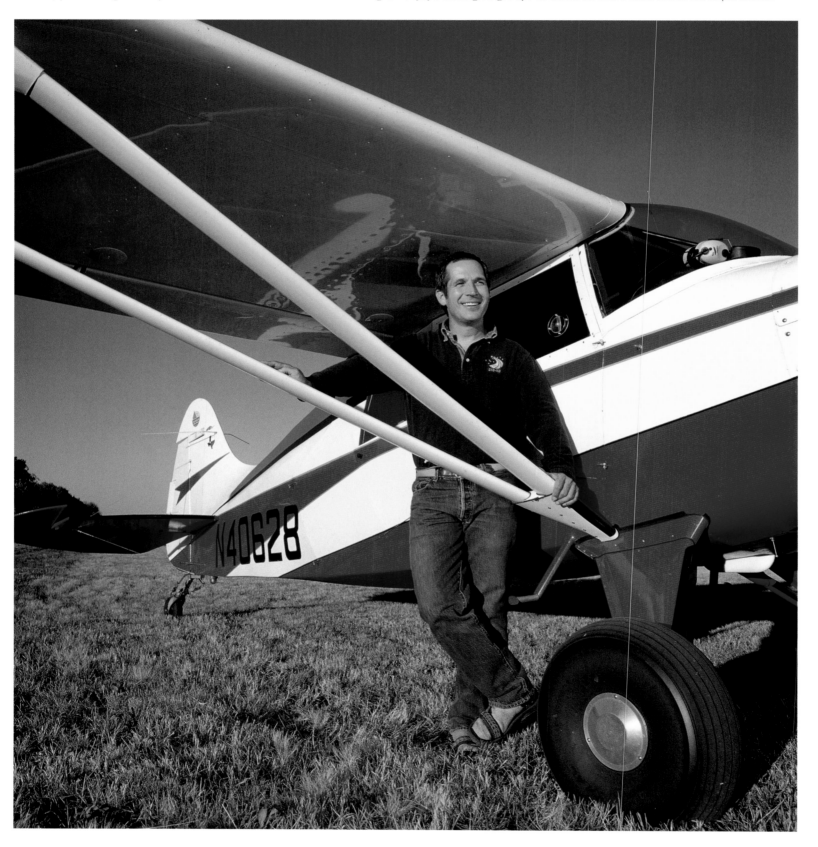

Daniel Worcester, national award-winning bladesmith and descendant of original enrollees Arlington Worcester and Nora Colbert Worcester, forges his unique knife blades from old steel files and fashions the handles from a variety of materials such as corn, dominoes, antlers, and coins.

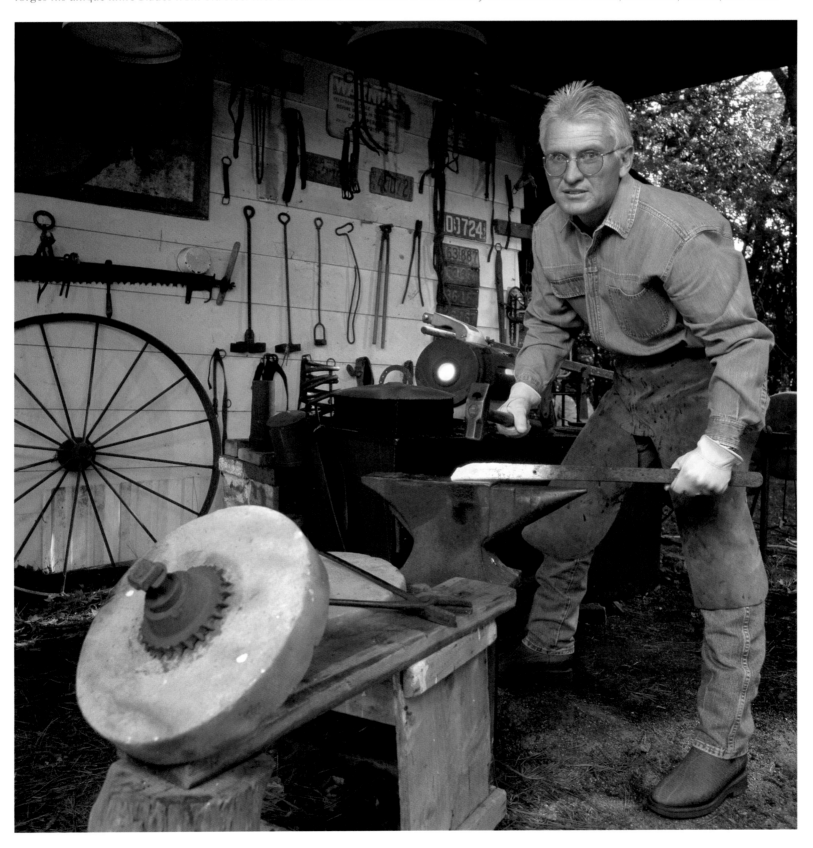

Chickasaw Hall of Fame inductee **Tom Phillips** dedicated his life to painting and sculpting to record and re-create the authentic history of Native Americans. Through his works, this highly acclaimed artist has chronicled important moments in Chickasaw culture and history.

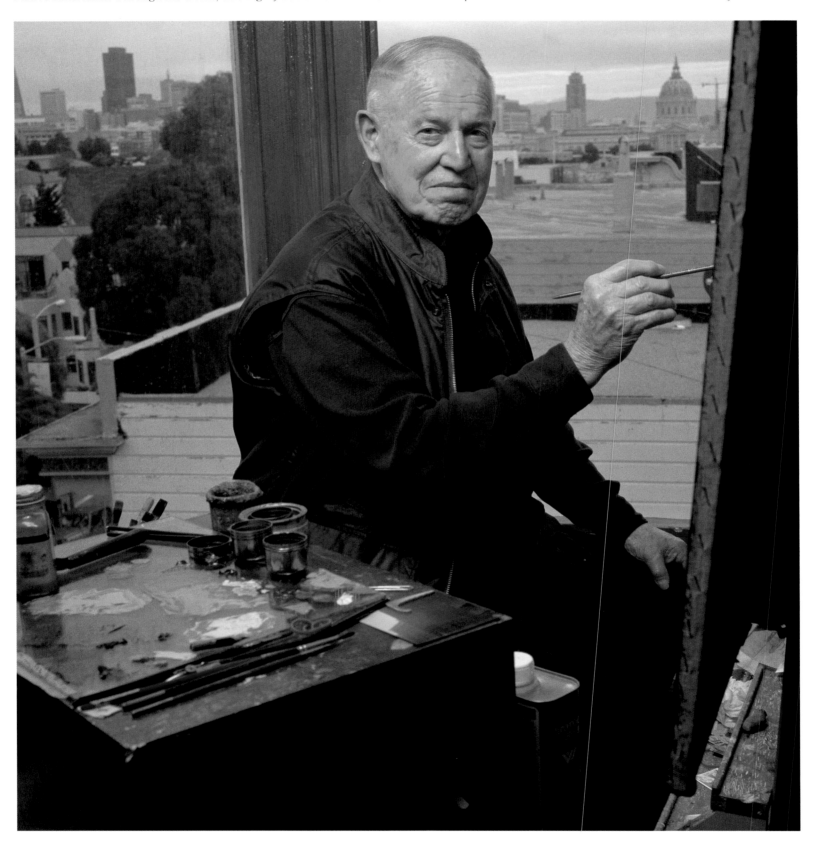

Brent Greenwood is a contemporary artist who expresses his American Indian heritage and the reality of living in two distinct worlds by creating pieces to reflect his knowledge of tribal history, culture, and activism.

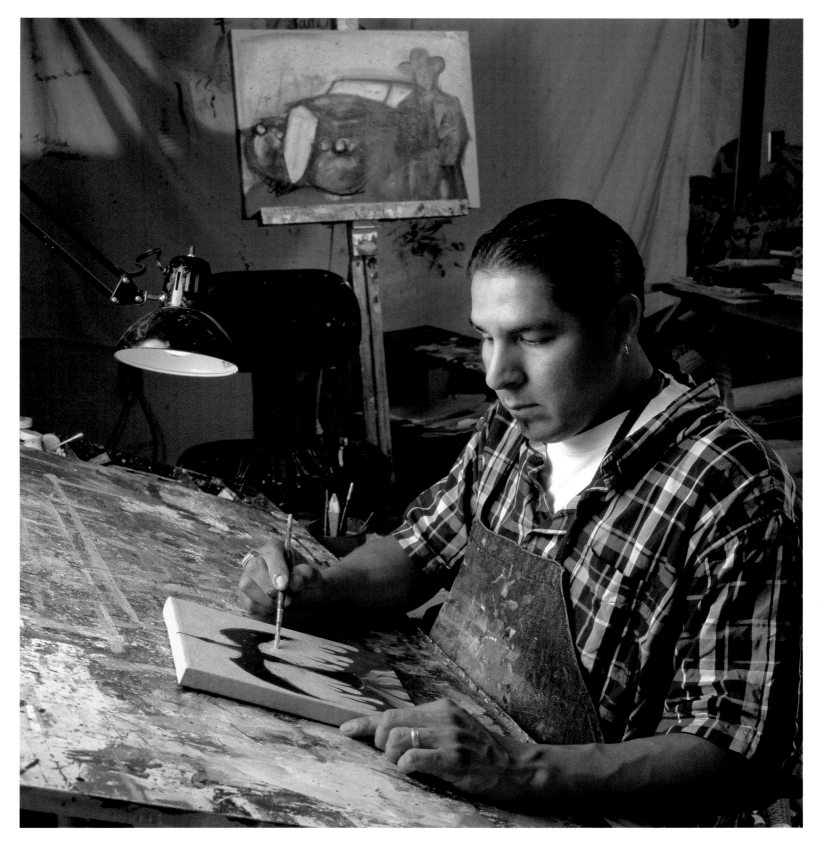

Raised in a traditional Chickasaw home, **LaDonna Brown** has come full circle as an anthropologist focusing on American Indian culture, with a special interest in archaeology.

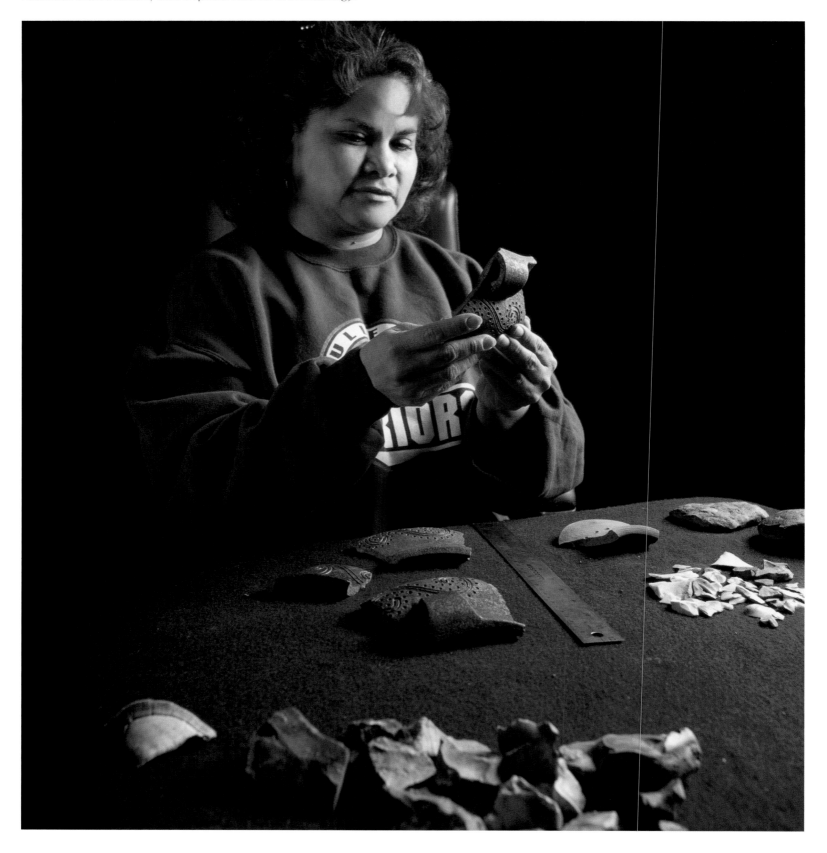

Joanna Underwood, Chickasaw artist, creates hand-coiled pottery by using commercial and native clays. Each piece is inspired by Southeastern designs of the Mississippian period and is smoked with cedar branches and pine needles.

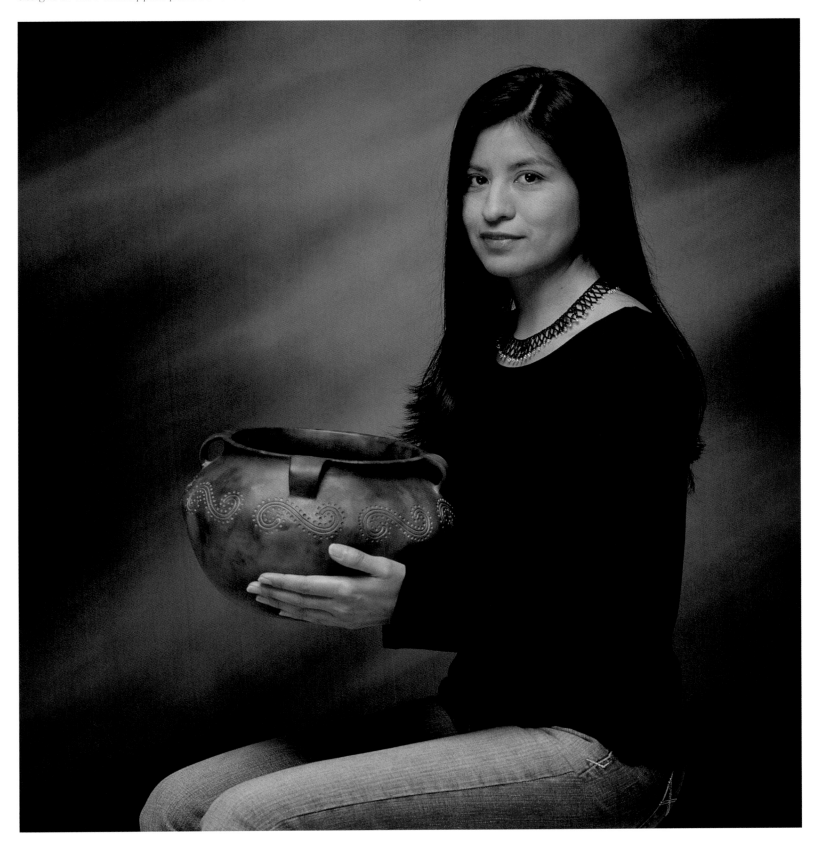

James Blackburn creates illustrations, knives, and jewelry, intertwining old Chickasaw ideas with contemporary themes in all his works.

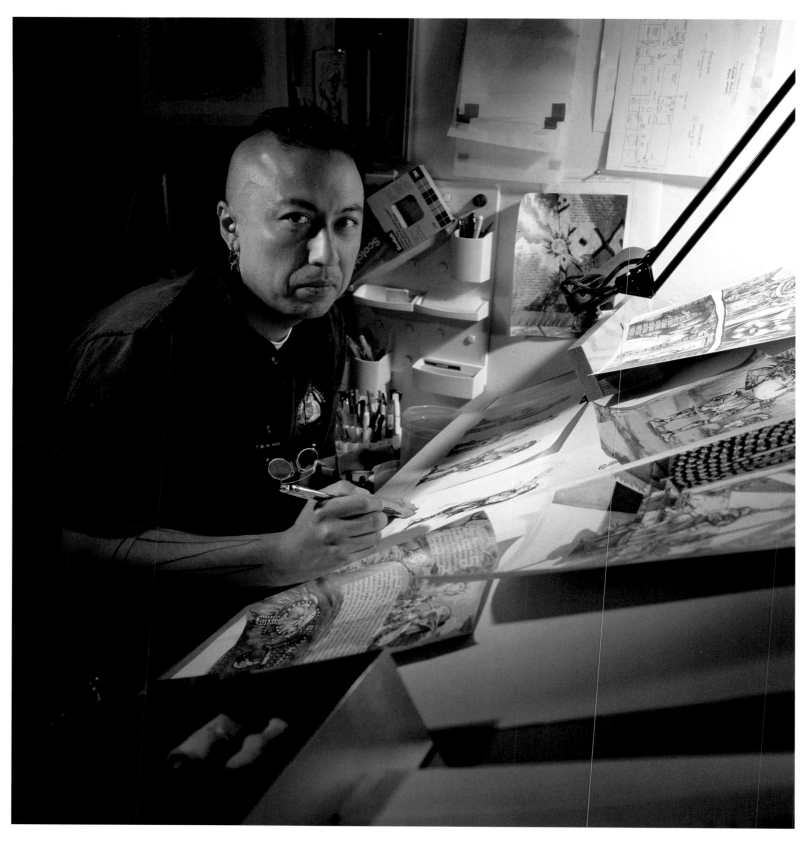

Many of **Norma Howard's** paintings are created from childhood memories and family stories told by her mother.
Her son **Daniel** creates his own style of painting and enjoys depicting cultural scenes such as stickball.

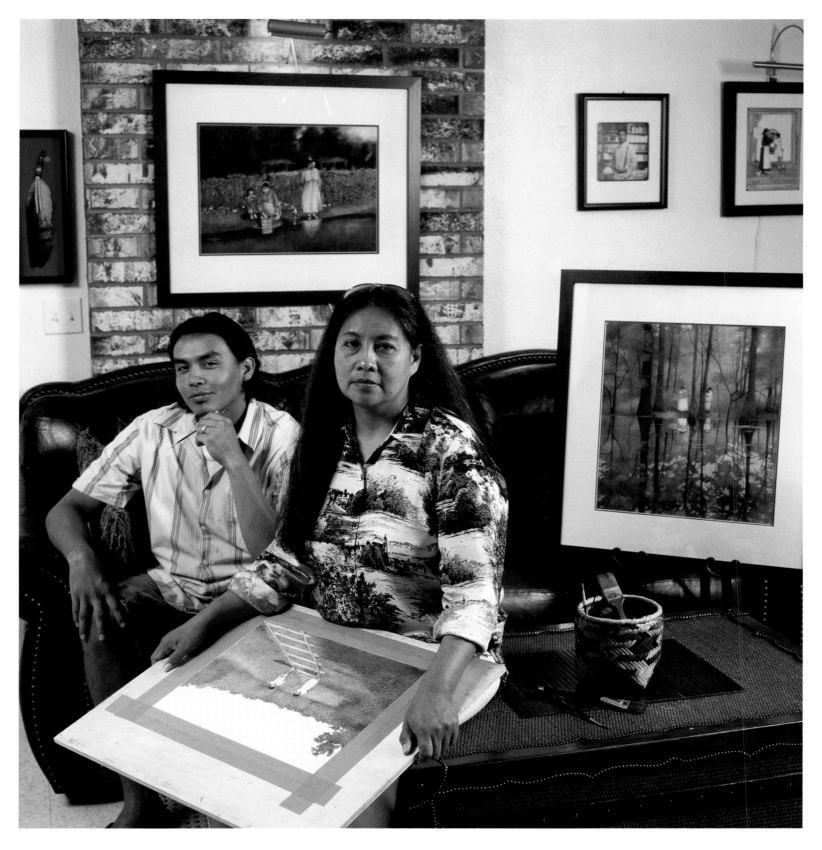

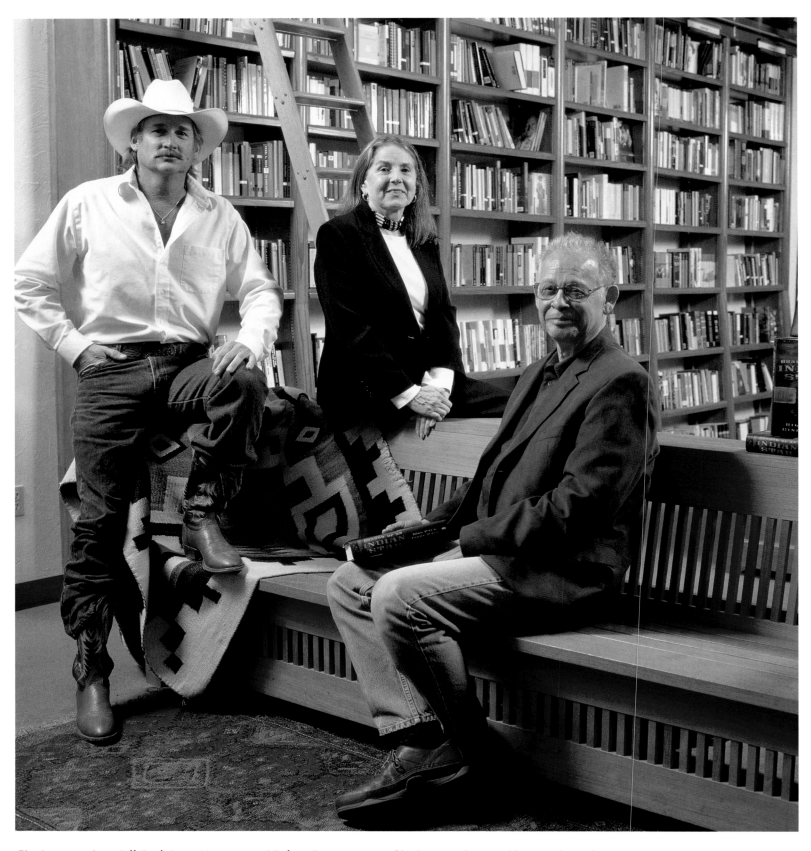

Chickasaw authors **Bill Paul**, **Lynn Moroney**, and **Robert Perry** preserve Chickasaw culture and history through published works depicting traditional tales, historical novels, and stories of cultural and ethnic folklore.

Award-winning author, playwright, and scholar **Dr. JudyLee Oliva** is highly regarded in both professional and academic theater. JudyLee spent twelve years researching and writing *Te Ata*, a theatrical production depicting the life of the famed Chickasaw storyteller and actress Te Ata Fisher. The play includes the author's original songs and lyrics.

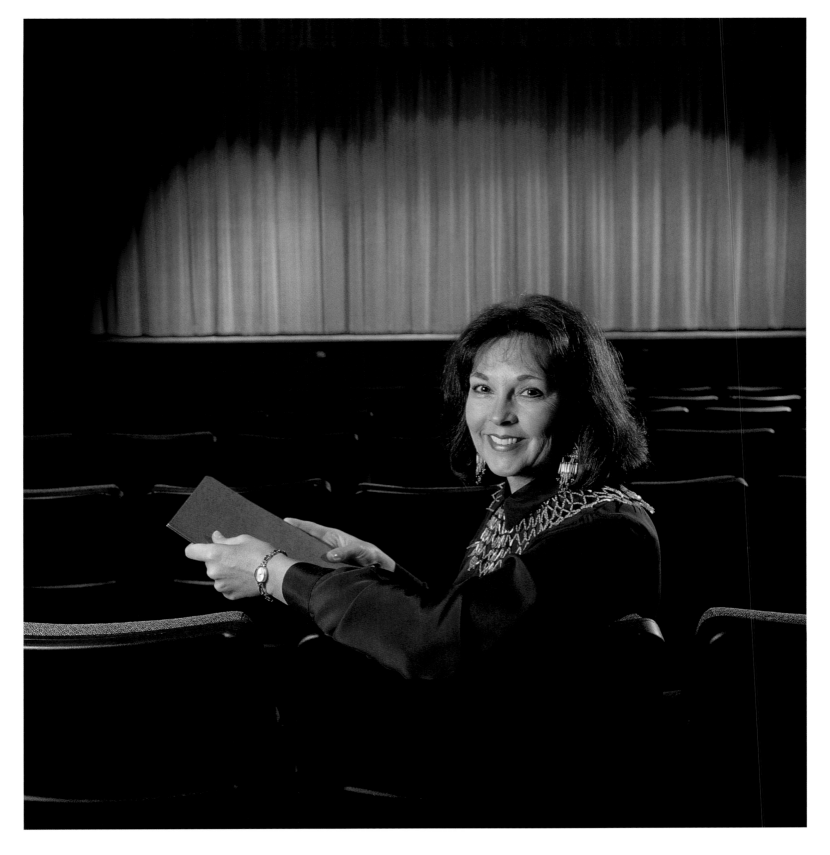

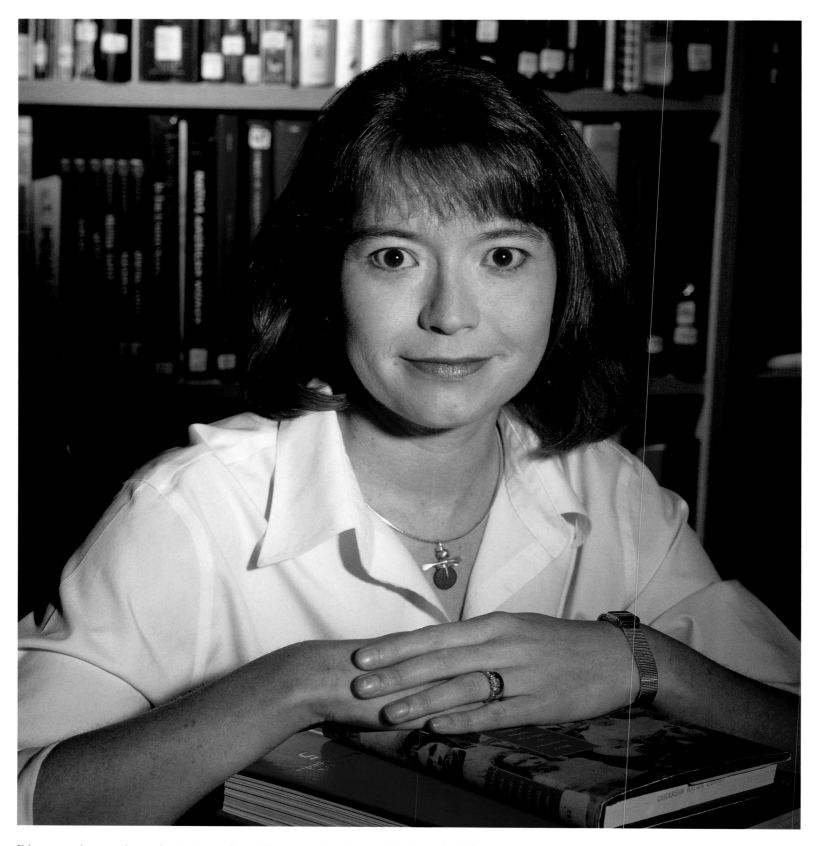

Educator, editor, and award-winning author of fiction and nonfiction, **Dr. Amanda Cobb** is an associate university professor specializing in Native American Studies.

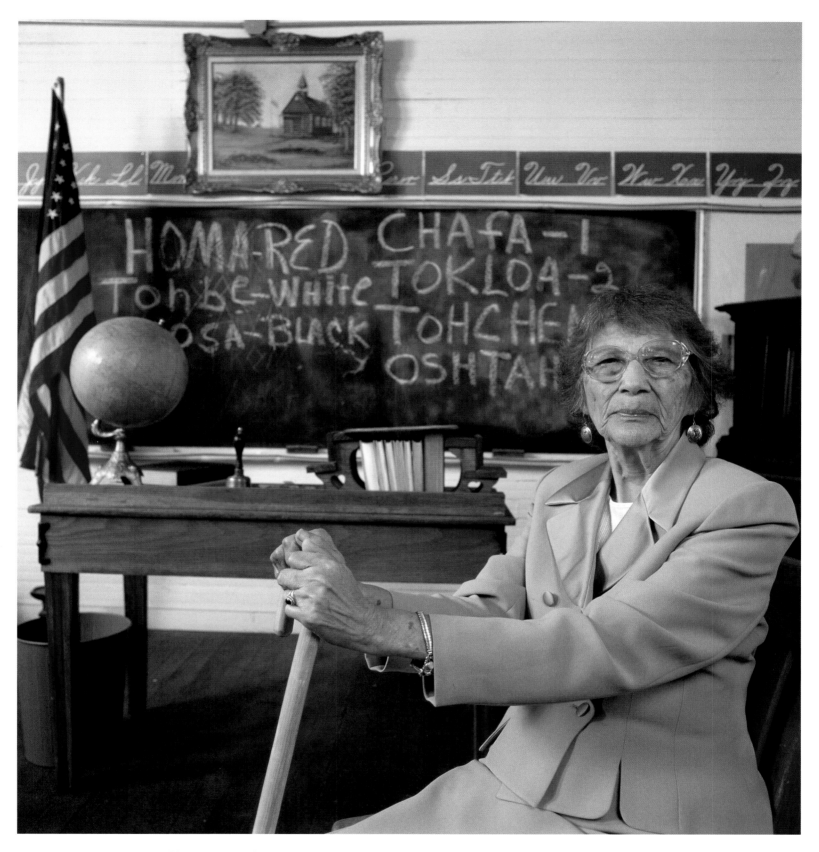

A cherished tribal elder, **Geraldine Greenwood** is honored by students and statesmen alike for her lifelong dedication to education, culture, and language preservation. Geraldine was inducted into the Chickasaw Hall of Fame in 2001.

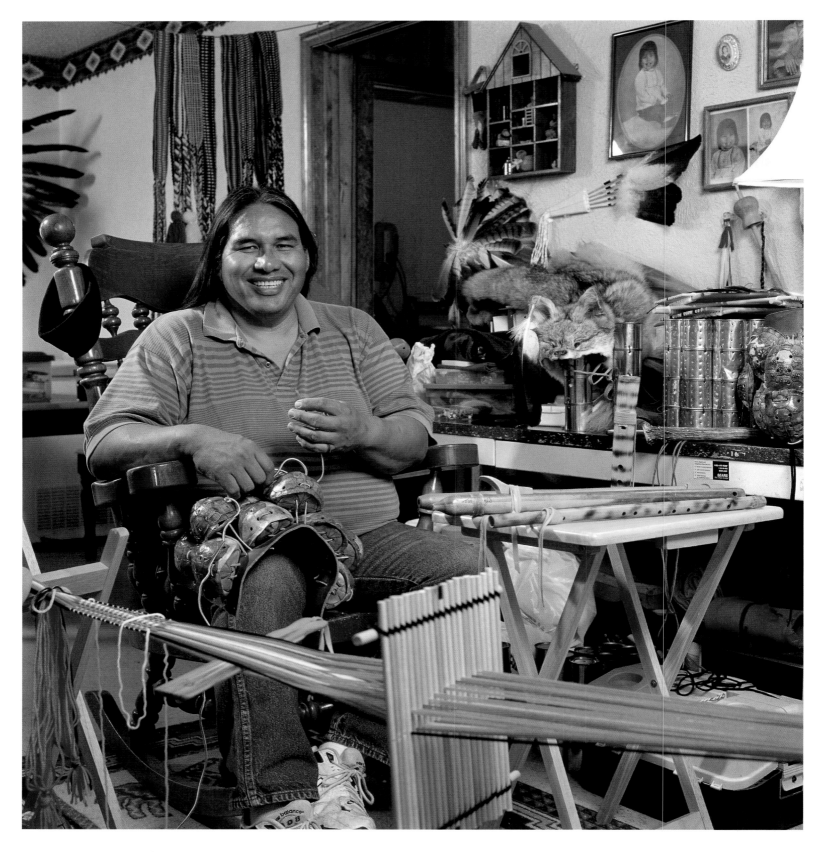

Tim Harjo believes his gifts come from the Creator and should be passed down to preserve our heritage.

His traditional crafts include shell shakers, woven stomp dance belts, flutes, and drums.

Kelley Lunsford has studied many traditional designs and also creates her own original contemporary patterns, weaving traditional belts, sashes, and split cane. Her woven cane mat won best in show at the 2005 Southeastern Art Show and Market.

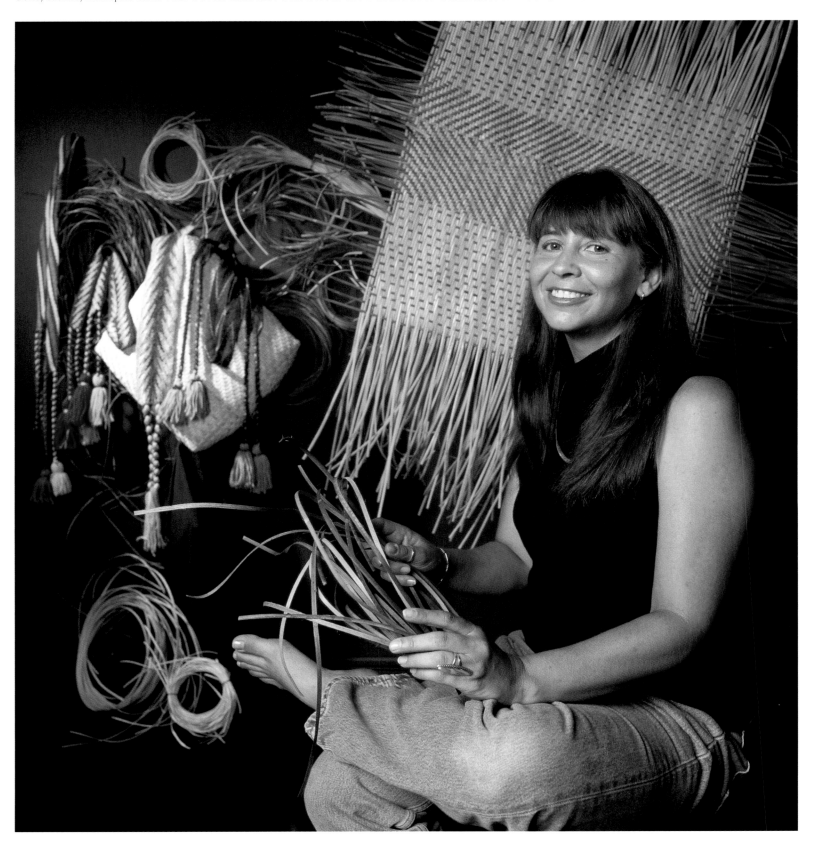

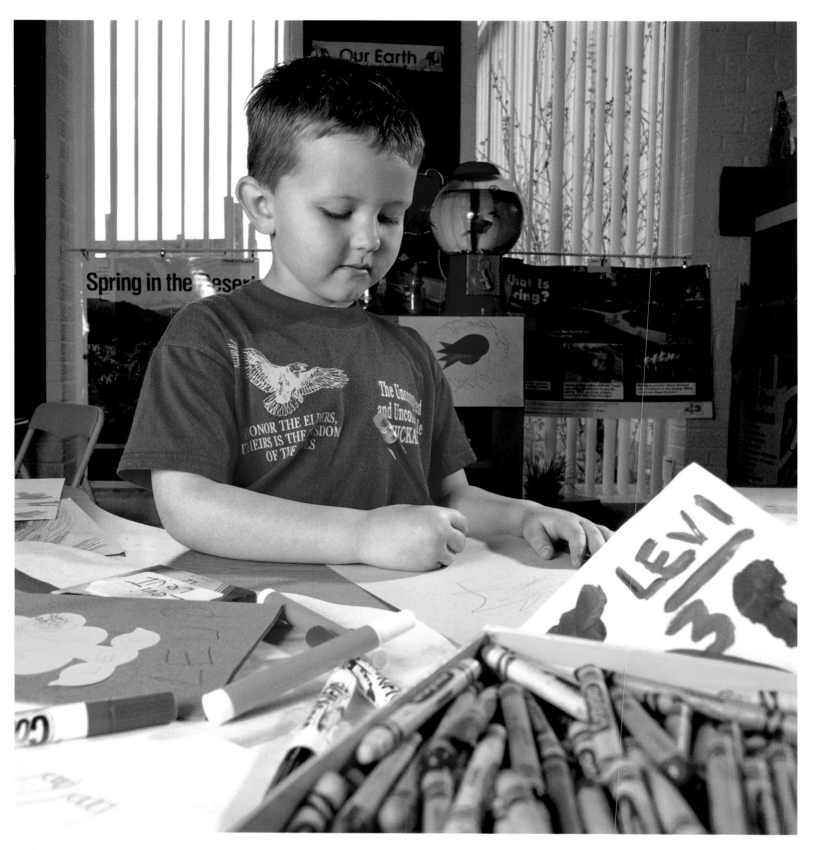

At five years of age, **Levi Hinson** loves to paint and draw and wants to be an artist when he grows up. He is a direct descendant of Itti' iwaambinili, Levi Colbert, and the son of Chickasaw artist Joshua Hinson.

Dr. Tina Cooper, progressive health advocate for the citizens of the Chickasaw Nation, was the first Chickasaw appointed as chief of staff at Carl Albert Indian Health Facility in Ada, Oklahoma.

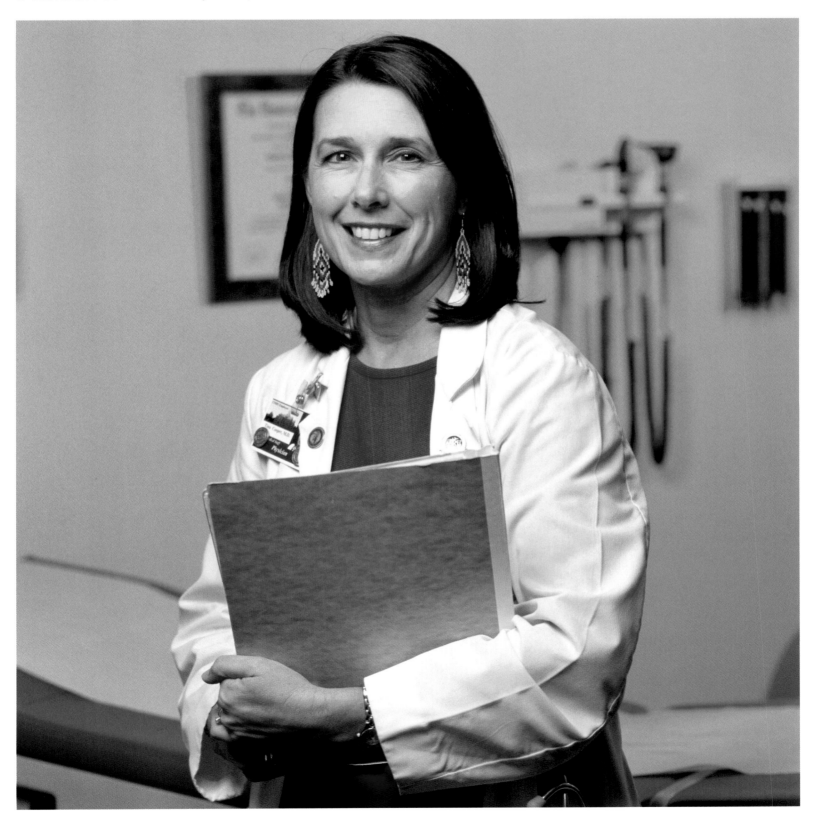

Dr. Judy Goforth Parker is a professor of nursing at East Central University in Ada, Oklahoma, and is nationally recognized for her efforts to further culturally sensitive diabetes education and intervention.

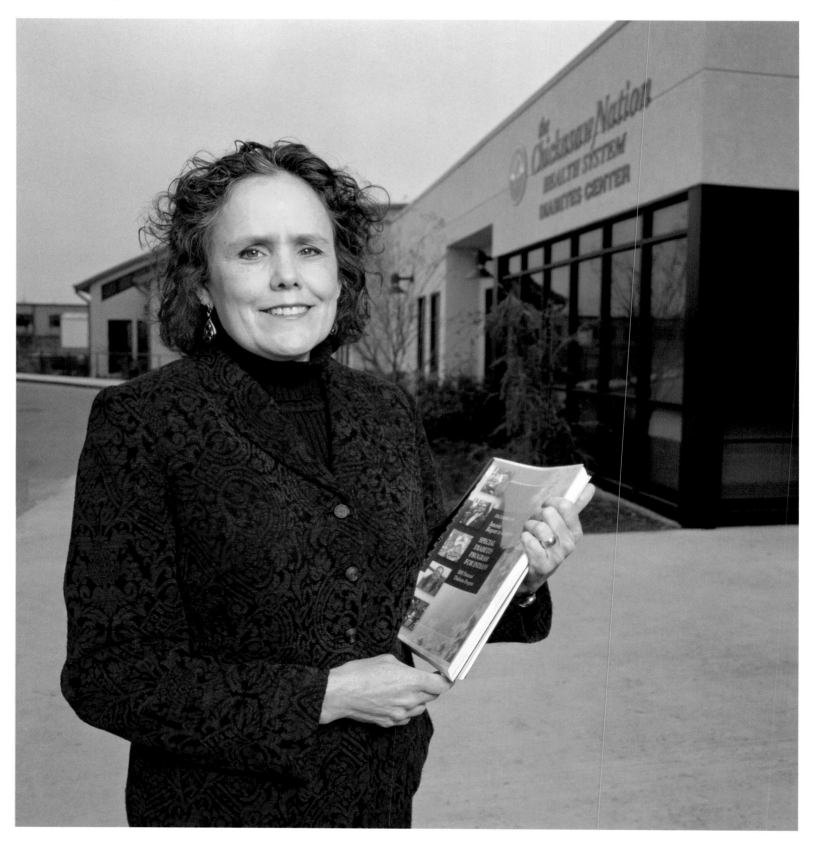

As past president of the Association of American Indian Physicians, **Dr. James Hampton** is a respected physician and oncology specialist. He has been honored as Indian Physician of the Year. Along with his daughter, **Dr. Diana Hampton**, an ophthalmologist, Dr. Hampton supports granddaughter and first-year premed student **Kira Chelberg**, and second-year medical student **Kalen Rogers** in their studies.

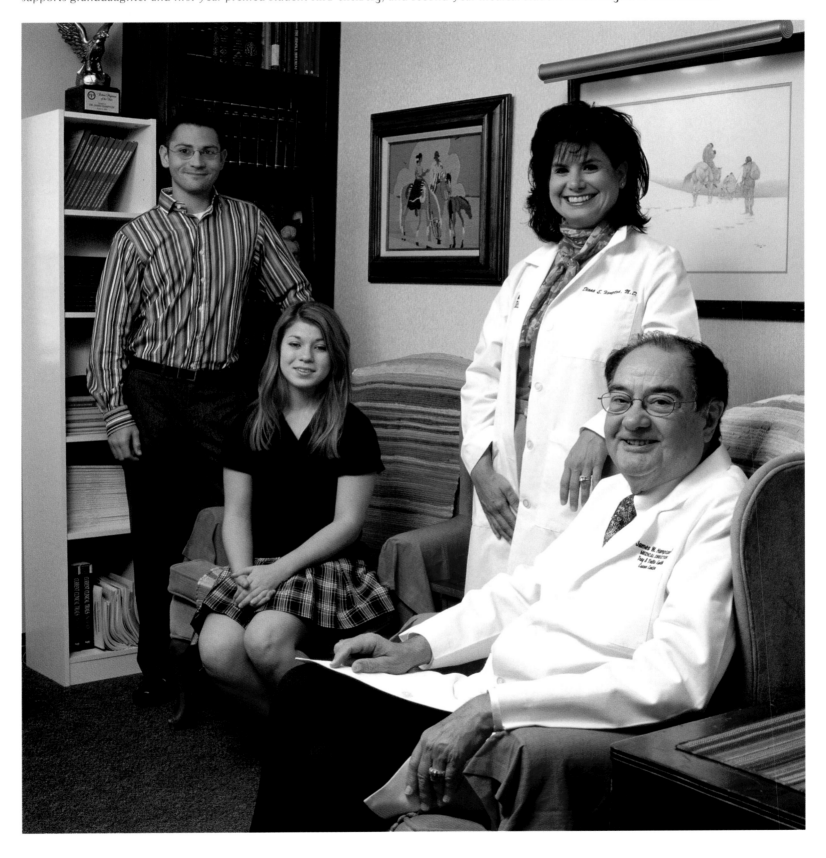

Governor Overton James became the twenty-ninth governor of the Chickasaw Nation when he was appointed to the job by President John F. Kennedy in 1963. He became the first elected governor of the Chickasaw Nation since 1906 when he was elected governor by the Chickasaw people in 1971. He was reelected every year he ran and retired in 1987.

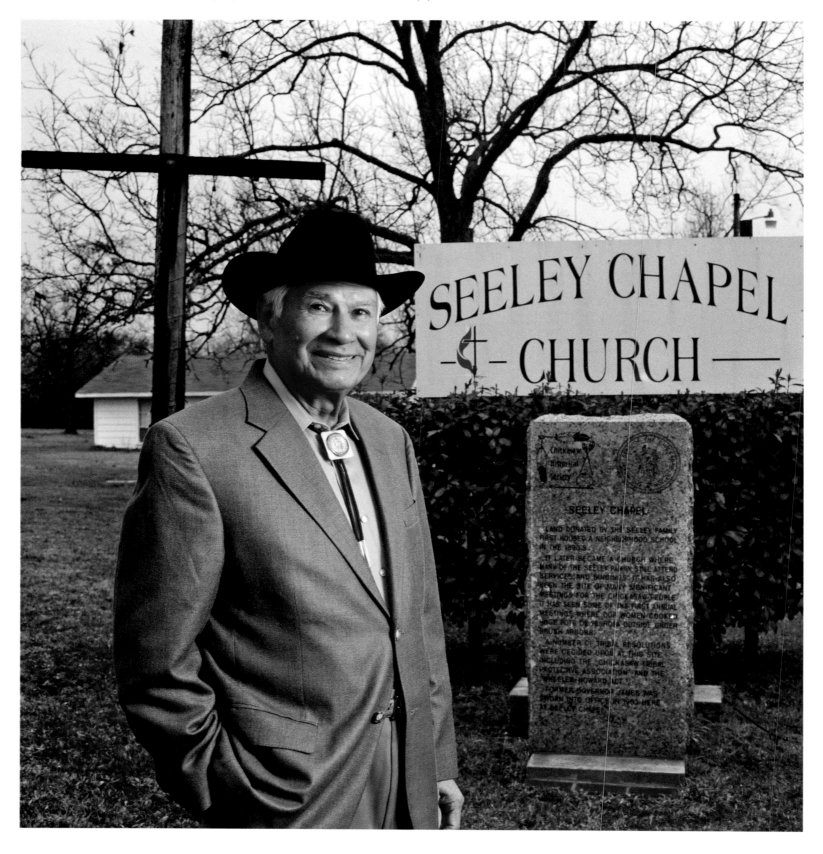

U.S. Representative **Tom Cole** serves in Oklahoma's 4th District. He is the son of former state senator
Helen Cole and is the great-grandnephew of famed Chickasaw storyteller Te Ata Fisher.

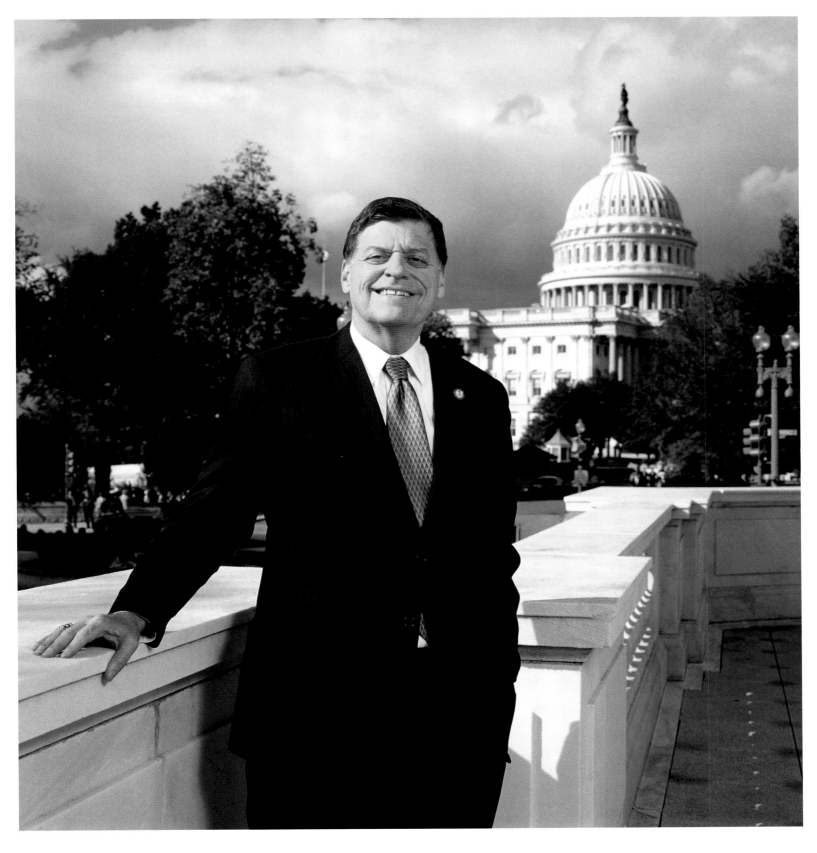

Chickasaws serving the state of Oklahoma include representatives **Ray McCarter** of Marlow and **Lisa Johnson Billy** of Purcell, assistant attorney general **Sherry Abbott Todd**, and former director of the Oklahoma Department of Transportation **Neal McCaleb**.

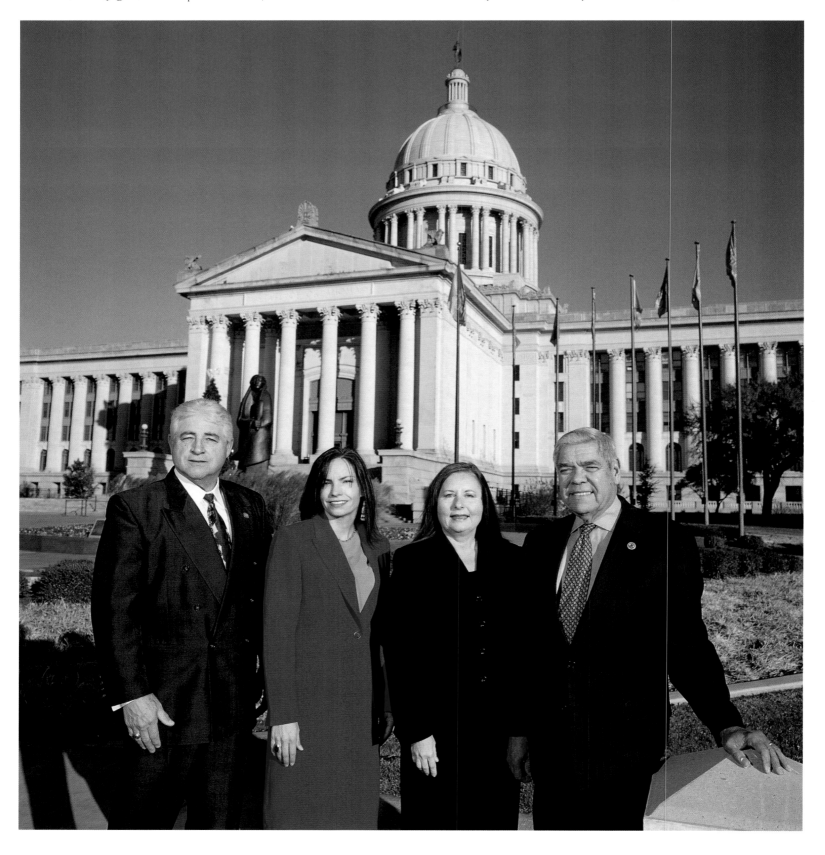

Our future and greatest resource, the families and children of the Chickasaw Nation.

The warrior tradition continues. Through the years, Chickasaws answer the call. Serving our country today are U.S. Army Major **Ted Scribner** (retired), Sergeant **Thea Stephens**, Specialist **Bradley J. Barrick**, and Chief Warrant Officer **Jay Mitchell**.

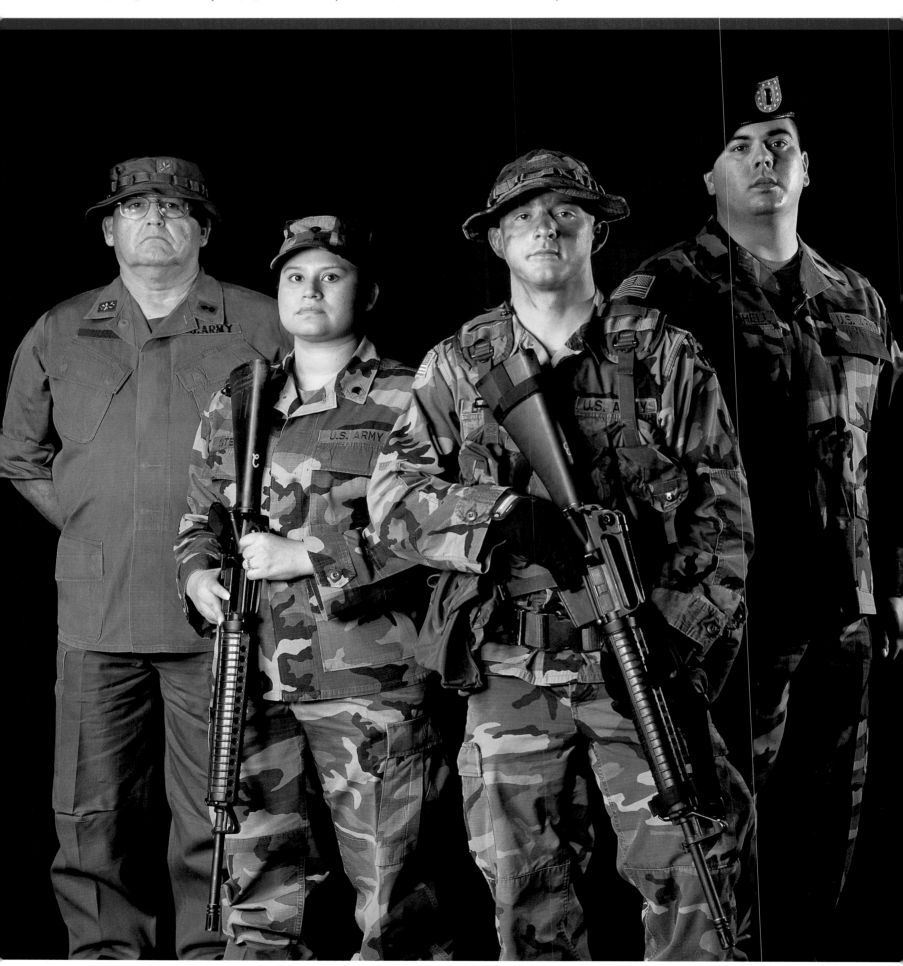

NATIVE AND AMERICAN

by David Ballard

We were here before this country had a name

And it's still the land of the free and the home of the brave

As we honor those who sacrificed their lives

WE STAND UP

With the spirit of the warrior inside us . . .

From the East to the West, we believe in freedom

From the North to the South

It's the RED, WHITE AND BLUE

And like the eagle flying high above this land I love

I'm proud to be *Native* and *American*

Desert stream and mountain sky

Fields and forest green

The land we're on is sacred

And we'll fight to keep it free

As we honor those who walked this road before—

WE STAND UP

With the spirit of the warrior inside us . . .

From the East to the West, we believe in freedom

From the North to the South

It's the RED, WHITE AND BLUE

And like the eagle flying high above this land I love

I'm proud to be *Native* and *American*

KNIFE AND SHEATH BY JAMES BLACKBURN.

ACKNOWLEDGMENTS

At the outset of creating a book of this magnitude, one never imagines how many individuals and entities will bring its form and substance into reality. With deepest gratitude we humbly thank all those who embarked on this journey with us—whose resources, time, talents, and long hours of hard work now tell the story of the Chickasaw.

To Governor Bill Anoatubby for casting a vision before your people that continually connects our Chickasaw heritage with our people's future. Thank you for wholeheartedly supporting this project.

To our friend and photographer, David G. Fitzgerald, an artistic visionary whose superlative abilities have so beautifully captured the life and spirit of an unconquered and unconquerable Chickasaw people. Thank you for this lasting legacy.

To our contributing writers, Jeannie Barbour, Dr. Amanda Cobb, Linda Hogan, Dr. Geary Hobson, and David Ballard—thank you for your vibrant expressions of history, culture, people, and art.

To Joanna Underwood for your tireless efforts as David's cultural liaison, who along with Julie Ray Burwell and Rachel Westmoreland managed photo shoots, subject matter, and photographs from beginning to end.

To our friends at Graphic Arts Center Publishing, Doug Pfeiffer, Tim Frew, Ellen Wheat, Kathy Howard, and Elizabeth Watson whose patience, professionalism, and creative leadership made publishers of us all.

To the Smithsonian Cultural Research Center for providing photography of important historical and cultural items.

To Natchez Trace Parkway in Mississippi, and Shiloh National Military Park in Tennessee, for local photo shoots.

To the many individuals employed by the Chickasaw Nation who helped to complete this book: the Chickasaw Council House Museum; the Divisions of Arts and Humanities, Heritage Preservation, Communications, and Commerce.

To those who contributed at many junctures from conception to print, Lona Barrick, Andrea Bahner, Matt Bradbury, Sheilla Brashier, Dixie Brewer, Gina Brown, John and Elaine Bruno, Rebecca Chandler, Gary Childers, Kyra Childers, Tony Choate, Laura Clark, Pat Cox, Matthew Cravatt, JoAnn Ellis, Robyn Elliott, Georgie Greenwood Frazier, Tammy Gray, Susan Green, Kelley Isom, Steve Jacob, Lisa John, Trina Jones, Stacy Lane, Glen Lemming, Aaron Long, Kristi Mitchell, Laura Morrison, Josh Newby, Carol and Rick Pate, Eddie Postoak, Bill Quincy, Jason Reed, Kelly Reed, Lorie Robins, Rainette Rowland, Kent Sanman, Ron Scott, Randy Shackleford, and Randi Woods. Thank you for your enthusiasm and assistance.

To the businesses and entities who so willingly gave of their time, equipment, and locations, Chief Danny Collins and Captain Steve Stanford of the Oklahoma National Guard in Ada, Oklahoma; West Sales of Ada, Oklahoma; Bedre' Chocolate Factory of Pauls Valley, Oklahoma; Arbuckle Emporium of Sulphur, Oklahoma; Arts & Heritage Center of Ada, Oklahoma; East Central University of Ada, Oklahoma; Jim Tolbert of Full Circle Book Store in Oklahoma City, Oklahoma; Chickasaw National Recreation Area in Sulphur, Oklahoma.

And to the many families and friends of the Chickasaw Nation, thank you for your graciousness as we joined together to give this book to the world.

—The Chickasaw Nation

► RED SPRINGS CHURCH AND CAMP HOUSES, NEAR ALLEN, OKLAHOMA, WERE THE SCENE OF WEEKLONG CAMP MEETINGS IN THE EARLY DAYS AND WERE MOSTLY SPIRITUAL IN NATURE, BUT ALSO A PLACE WHERE PEOPLE CAME TO SHARE INFORMATION ABOUT FAMILIES, COMMUNITIES, EVENTS, AND TRIBAL AFFAIRS. THEY HELPED TO MAINTAIN A SENSE OF IDENTITY AND CULTURE THROUGH THE DIFFICULT YEARS AND LAID A FOUNDATION FOR A STRONG, VIBRANT CHICKASAW NATION.

Governor Anoatubby, for his vision of this great project.

My friend, Lona Barrick, whose steadfast direction kept me on the straight and narrow path to our goal.

The talented artist Jeannie Barbour, whose historical expertise enlightens us through her text.

My liaison, Joanna Underwood, whose strategic assistance made these photographs possible; also appreciated are her assistants, Rachel Westmoreland and Julie Ray Burwell.

My publishing friends and colleagues, Doug Pfeiffer and Tim Frew, with whom I shared this great Chickasaw adventure.

Betty Watson, for her consistently incredible design; she always excels.

My photo assistant, Rainette Rowland, whose help with key photo sessions was invaluable.

Most of all, I thank the Chickasaw people whose warmth and understanding of this project made these photographs a reality.

—David G. Fitzgerald

FURTHER READING

HISTORY

The History of the American Indians, by James Adair (London: E. C. Dilly, 1775). Adair was well acquainted with the Chickasaws. He traded with them for years (circa 1744 to 1768) and was known as the "English Chickasaw." This book provides an extensive account of the Chickasaws on pages 352–73.

The Chickasaws, by Arrell Morgan Gibson (Norman: University of Oklahoma Press, 1971). This book offers the most recent comprehensive history of the Chickasaws. It includes many illustrations and a good bibliography. It does not contain much more information than James Malone's *The Chickasaw Nation*.

The Chickasaw Nation: A Short Sketch of a Noble People, by James Henry Malone (Louisville, Kentucky: J. P. Morton, 1922). This book was the available history book on the Chickasaws until Gibson's book was published in 1971. It begins with de Soto's narrative, and provides a comprehensive history based on information considered factual at the time it was written. The book has illustrations, a map, and bibliography. The first six chapters were printed for private distribution in 1919.

The Chickasaw People, by W. David Baird (Phoenix, Arizona: Indian Tribal Series, 1974). This book begins with the story of the migration. It is a brief but clear factual history, and offers much about current improvement programs. The book is illustrated, with photos of significant Chickasaws including Overton James, Te Ata (Mary Thompson), Georgia Brown, Abijah Colbert, Ah-it-To-Tubby, and Nelson Chigley. It has maps, one showing counties in the old Chickasaw Nation.

The Indians of the Southeastern United States, by John R. Swanton (Washington, D.C.: Smithsonian Books, 1978). This volume on Southeastern Indians presents discussions of each tribe and their population. The Chickasaws are discussed throughout the book, and are specifically addressed on pages 116–19.

Splendid Land, Splendid People: The Chickasaw Indians to Removal, by James Atkinson (Tuscaloosa: University of Alabama Press, 2003).

Listening to Our Grandmothers' Stories: The Bloomfield Academy for Chickasaw Females, 1852–1949, by Amanda J. Cobb (Lincoln: University of Nebraska Press, 2000).

Historic Oklahoma, by Paul Lambert, Kenny A. Franks, and Bob Burke (Oklahoma City: Oklahoma Heritage Association, 2000).

Chickasaw Nation Constitution: Constitution, Treaties, and Laws of the Chickasaw Nation, made and enacted by the Chickasaw Legislature (Atoka, Indian Territory: Indian Citizen Print, 1890).

A Guide to the Indian Tribes of Oklahoma, by Muriel Wright. (Norman: University of Oklahoma Press, 1951).

BIOGRAPHY

Te Ata: Chickasaw Storyteller, American Treasure, by Richard Green (Norman: University of Oklahoma Press, 2002).

The Chickasaw Rancher, by Neil R. Johnson (Stillwater, Oklahoma: Redlands Press, 1961). This book addresses the life of Montford Johnson, a Chickasaw mixed-blood who ranched in the Nation from 1861 to 1896. It offers a good picture of life in the Chickasaw Nation, as well as of ranching in Indian Territory.

LANGUAGE

Introduction to Chickasaw, A Language Learning Program, by Carlin Thompson et al. (Richardson, Texas: Indian Peoples Publishing, 1993).

A Chickasaw Dictionary, compiled by Jesse Humes and Vinnie May (James) Humes.

Chickasaw: An Analytical Dictionary, by Pamela Munro and Catherine Willmond (Norman: University of Oklahoma Press, 1995).

FICTION

Life with the Little People, by Robert J. Perry (Greenfield Center, New York: Greenfield Review Press, 1998).

Shadow of an Indian Star, by Bill and Cindy Paul (Austin, Texas: Synergy Books, 2005).

Mean Spirit, by Linda Hogan (New York: Atheneum, 1990).

Solar Storms, by Linda Hogan (New York: Scribner, 1995). A young woman returns to the northern lands of her relatives and travels with them by canoe to northern Quebec.

Shell Shaker, by LeAnne Howe (Aunt Lute Books, 2001).

ANTHOLOGIES

The Remembered Earth: An Anthology of Contemporary Native American Literature, by Geary Hobson (Albuquerque: University of New Mexico Press, 1981).

PERFORMING ARTS

New Theatre Vistas: Modern Movements in International Theatre, by JudyLee Oliva (New York: Garland Press, 1996).

David Hare: Theatricalizing Politics, by JudyLee Oliva (Ann Arbor, Michigan: UMI Research Press, 1991).

ARTICLES

"The Chickasaw Wars of 1736 and 1740: French Military Drawings and Plans Document the Struggle for the Lower Mississippi," by Joseph L. Peyser. *Journal of Mississippi History*, 44:1 (1982), 1–25. The Chickasaws defeated the French in 1736 on the Tombigbee. These defeats called for siege plans and drawings by the French military for use in Bienville's campaign against the Chickasaws in 1740. This article offers a translation of the documents and traces the events leading up to the French campaign against the Chickasaws.

"Chief Tishomingo: A History of the Chickasaw Indians and Some Historical Events of their Era, 1737–1839," by Cecil Lamar Summers. American Revolution Centennial Ed. Iuka, MS: N.p., (1974). Includes history, legends, Tishomingo, de Soto, the Colberts, Piomingo, Cyrus Harris, Sam Houston, Davy Crockett, Reelfoot Lake and Sam Dale, James Bowie, outlaws, treaties, and more. Illustrated with photos.

"Social and Religious Beliefs and Usages of the Chickasaw Indians," by John R. Swanton. *Bureau of American Ethnology, Forty-Fourth Annual Report*. Washington, D.C.: Government Printing Office (1926), 169–263. Swanton attempts a comprehensive account of the Chickasaws as he had done with the Creeks. Includes migration legend, social organization, customs, property rights, crime and punishment, and much more.

"Bloomfield Academy and its Founder," by Sarah J. Carr. *Chronicles of Oklahoma* 2 (#4 1924), 369–70.

"Survey of Education in Eastern Oklahoma from 1907 to 1915," by Joe C. Jackson. *Chronicles of Oklahoma* 29 (summer 1951): 201–2.

"Bloomfield Academy," by Irene B. Mitchell. *Chronicles of Oklahoma* 49 (Winter 1971–72): 412.

INDEX